THE JOSEPH WINTERBOTHAM COLLECTION

A LIVING TRADITION

THE ART INSTITUTE
OF CHICAGO

© 1986 The Art Institute of Chicago.
All rights reserved.

Library of Congress
Catalog Card Number 85-73682
ISBN 0-86559-070-2

Executive Director
of Publications:
Susan F. Rossen

Designed by
Lipman and Simons, Inc.
Chicago, Illinois

Typography by
Paul Baker Typography, Inc.,
Evanston, Illinois

Printed by
Dai Nippon Printing Company,
Tokyo, Japan

Photography Credits
All color photographs by
Kathleen Culbert-Aguilar,
Chicago, except pp. 29, 31, 34, 37, 48, 51,
which were taken by
the Art Institute's Department
of Photographic Services.

Thanks are due to many who helped bring this book to publication: Lyn DelliQuadri, Associate Editor of Publications, for her excellent essay and the management of the book's production; Publications Assistant Holly Stec Dankert for her diligent bibliographic research, which was aided by Andrea Hales and Mary Kuzniar from the departments of Twentieth-Century Painting and Sculpture and of European Painting, respectively; Susan F. Rossen, Executive Director of Publications, for her skillful editing; and Courtney Donnell, Assistant Curator of Twentieth-Century Painting and Sculpture, for her wise counsel. Katharine Kuh, former Art Institute Curator of Modern Painting and Sculpture, shared pertinent anecdotes and facts on the formation of the Winterbotham Collection. The Chicago Historical Society and the Newberry Library provided valuable aid in uncovering photographs and reconstructing the early history of the Winterbotham family. In this regard, Mrs. Theodora Winterbotham Brown, granddaughter of Joseph Winterbotham, was also most generous. Members of the Winterbotham Committee at the Art Institute are to be thanked for their continued interest and support of this project: A. James Speyer, Curator of Twentieth-Century Painting and Sculpture; James W. Alsdorf, Life Trustee; and Patrick Shaw, Winterbotham family representative.

James N. Wood
Director

Library of Congress Cataloging-in-Publication Data

Art Institute of Chicago.
 The Joseph Winterbotham Collection.

 Bibliography: p.
 1. Painting, European. 2. Painting, Modern—19th
century—Europe. 3. Painting, Modern—20th century—
Europe. 4. Painting—Illinois—Chicago.
5. Winterbotham, Joseph Humphrey, 1854–1925—Art
patronage. 6. Art Institute of Chicago. I. Title.
ND457.A7 1986 759.05′074′017311
85–73682
ISBN 0-86559-070-2

TABLE OF CONTENTS

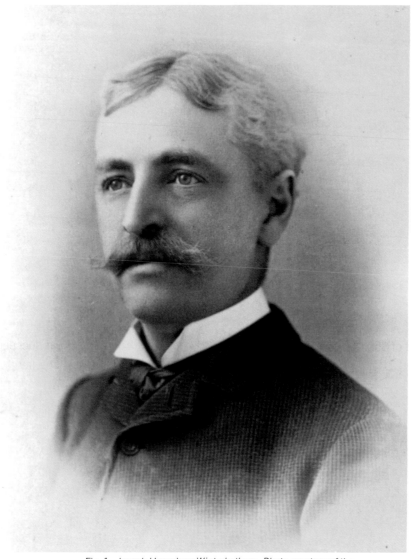

Fig. 1. *Joseph Humphrey Winterbotham. Photo courtesy of the Winterbotham family.*

THE WINTERBOTHAM PLAN

James N. Wood

In 1921, during the Art Institute's fledgling years, Joseph Winterbotham had a remarkable and farsighted idea for bringing European painting to Chicago. Mr. Winterbotham was a businessman and not a collector of art, but he traveled widely, often to Europe, and understood the importance of fine art to the cultural life of a community. The plan he formulated in the first decades of the twentieth century was greeted with an enthusiasm that still endures as we approach the century's end. It has provided the Art Institute with an increasingly valuable group of late nineteenth- and twentieth-century paintings, many of which stand among the masterpieces of the museum's holdings.

The Winterbotham Plan was unique in its day, and, to my knowledge, no other major museum has had a comparable arrangement. In the following essay, "A Living Tradition: The Winterbothams and Their Legacy," the Winterbotham family and plan are discussed in detail. Suffice it to say here that the plan began with a gift of $50,000, which was to be invested and maintained as principal, and its interest was to be used for the purchase of paintings by European artists. The key stipulation of the plan was that initially only thirty-five paintings should be purchased. Once that number was attained, which occurred in 1946, any work could be sold or exchanged for a work of superior quality and significance to the collection. In this way, Joseph Winterbotham created a living tradition — a collection of paintings that in the course of sixty-five years has continually changed in scope and improved in strength.

The Winterbotham Plan has come to be known as the Art Institute's first commitment to the acquisition of modern art. Although Joseph Winterbotham indicated only that acquisitions be of works by European artists, the first painting bought under the plan — Henri Matisse's 1919 canvas *Woman Standing at the Window* — set the stage for a collection with a decidedly contemporary complexion. Between 1921 and 1929, ten of the thirteen paintings then acquired for the Winterbotham Collection had been created in the twentieth century. The remaining three were by Post-Impressionists, artists central to the development of Modernism, and included the Art Institute's first painting by Paul Gauguin, *The Burao Tree (Te Burao)* (p. 18), which has

remained in the Winterbotham Collection to the present day. This trend in selecting contemporary paintings seemed to have met with the approval of the collection's founder. Shortly before he died, he wrote to the museum's vice-president, "I congratulate the Art Institute and myself on the fine discrimination you have heretofore exercised in selecting paintings."

In the course of the first fourteen years of purchasing under the Winterbotham Plan, a committee of Art Institute trustees often made selections on the advice of members who traveled frequently to Europe and were well acquainted with the galleries of Paris and London. As time passed, the considerable involvement of Joseph Winterbotham, Jr. in this selection process justified a reconstitution of the Winterbotham Committee to include a family member, one trustee, and the museum's director. After Joseph Winterbotham, Jr. died, he was succeeded by his niece Rue Winterbotham Shaw, a central figure in Chicago's art world for many decades, and she, in turn, was succeeded by her son Patrick Shaw, who represents the family today.

By 1947, when the group of thirty-five paintings was finally in place, the first exhibition of the complete collection was mounted. At this time, it became clear that the pictures would be seen to better advantage interspersed among the museum's growing holdings of nineteenth- and twentieth-century European art. The Gauguins, Cézannes, van Goghs, and the great Toulouse-Lautrec bought for the Winterbotham Collection found their natural places next to the Impressionist and Post-Impressionist paintings that had been given in subsequent years by some of the Art Institute's other major patrons. The Cubist works by Picasso and Braque, the Modigliani portrait, the monumental early Chagall, and the Surrealist canvases by de Chirico, Dali, and Tanguy gravitated to their rightful positions among the museum's burgeoning twentieth-century acquisitions. It was the recognition of this fact that moved Joseph Winterbotham, Jr. to propose, in 1945, a change in his father's original provision for a room devoted to the permanent exhibition of the Winterbotham Collection. He suggested, instead, that the thirty-five paintings be brought together for exhibition one month a year.

Since then, the annual gathering of the Winterbotham Collection has been accompanied by a regular reassessment

of the whole and its parts. Over the years, various members of the Winterbotham family have offered or bequeathed paintings to the collection — Joseph Winterbotham, Jr. being a particularly active and generous donor. Opportunities arose to purchase important works by such modern pioneers as Miró and Delaunay, and later it was deemed wise to increase the collection's scope by adding works of more contemporary masters; thus came examples by Nicholson, Balthus, and Dubuffet. Witnessing the collection's changing composition has been a stimulating experience for both the curatorial staff and the public. However, as the years have passed and finer and finer paintings have taken their places within the group, fewer and fewer have been considered for replacement or exchange.

It is inevitable, given the nature of the Winterbotham Plan, that the thirty-five paintings now comprising this special collection will undergo further culling and change. Nevertheless, we are exceedingly proud of the shape and quality it has taken in the course of its sixty-five year history, and we have sought, with the publication of this catalogue, to honor the Winterbotham Collection, its founder, and the family that has nurtured it to its present distinction.

A LIVING TRADITION: THE WINTERBOTHAMS AND THEIR LEGACY

Lyn DelliQuadri

By the 1920s, less than one hundred years after its founding, Chicago had been transformed from a prairie swampland to an exuberant industrial and cultural metropolis. Skyscrapers, stock yards, steel mills, streetcars, wharfs, warehouses, locomotives, automobile-clogged streets, and lake-going vessels laden with grain and coal announced an unprecedented prosperity. There was opera, theater, a symphony orchestra, Jelly Roll Morton and Louis Armstrong; the literary achievements of Carl Sandburg, Sherwood Anderson, Theodore Dreiser, and Edna Ferber; the newly opened Field Museum of Natural History; The Art Institute of Chicago, whose Italian Renaissance facade was already blackened and stained from nearly three decades fronting Michigan Avenue. Some sources attributed the city's wealth and progress to "prairie energy." Frank Lloyd Wright, himself endowed with it, and, by then, building his own architectural legend, remarked that "The real American spirit... lies in the West and Middle West, where breadth of view, independent thought, and a tendency to take common sense into the realm of art, as in life, are more characteristic."[1] Of such a spirit the Winterbothams were made.

Joseph Humphrey Winterbotham (fig. 1) was born in Columbus, Ohio, in 1852. He settled in Joliet, Illinois; married Genevieve Baldwin of New Haven, Connecticut; and raised four children. The Winterbotham family moved to Chicago in 1892, where Joseph Winterbotham became engaged in various successful business enterprises. During the course of his life, he organized no less than eleven corporations, including cooperage manufacture, moving and transfer, and mortgage financing. A practical-minded man, he sent his sons, John and Joseph, Jr., to Yale and his daughters, Rue and Genevieve, to Europe. After his wife died in 1906, he lived in an apartment in the Virginia Hotel, a building at the intersection of Ohio and Rush Streets that was considered one of the first and finest of "modern," luxury apartment dwellings. Europe, with its rich cultural texture, seems to have captured his fancy, and he enjoyed frequent travel there, sending back photographs of himself stepping into Venetian gondolas and browsing in Parisian quarters. By all accounts, he was intelligent and witty, without pomposity or pretension. He remained close to his family, brought his sons

into his businesses, encouraged his daughter Rue in her passionate involvement with the arts, and regularly invited his grandchildren for Sunday breakfast at the Virginia Hotel.

Rue Winterbotham (fig. 3) inherited the independence and energy of her father and undoubtedly helped shape his taste in and commitment to art. She was an accomplished linguist and talented interior decorator. With her husband, musician and composer John Alden Carpenter, she spent a great deal of time in Europe, becoming acquainted with the avant-garde artists, dancers, and composers of the early twentieth century.

Since the Chicago of the World War I era had few art galleries and the Art Institute's collection at that time was largely dependent on the taste of its benefactors, who preferred earlier artistic expressions, Rue Winterbotham Carpenter took it upon herself to establish a Chicago outpost for contemporary art. In 1916, more than a decade before the opening of New York's Museum of Modern Art, she helped found the Arts Club of Chicago, which continues to this day to be a center for the exhibition and discussion of current artistic activity. Rue's father and brothers were among the club's first members. Two years later, she became its president, retaining the office until her death in 1931. She designed the interiors of the club's several locations and took on its mission of fostering and developing the highest

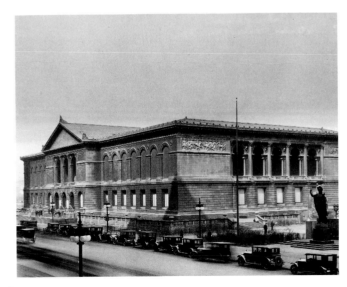

Fig. 2. *The Art Institute of Chicago, c. 1921. Photo courtesy of The Art Institute of Chicago archives.*

standards of art. She organized first showings in Chicago of drawings by Pablo Picasso; sculpture by Auguste Rodin, Gaston Lachaise, and Constantin Brancusi; paintings by Georges Braque, Marie Laurencin, and American modernists Davies, Marin, Schamberg, Sheeler, and Stella. During her tenure, Rue Winterbotham Carpenter produced an astonishing list of one-man exhibitions by European artists Joan Miró, Georges Rouault, Jacques Villon, and Fernand Léger — all little known in America at the time. Broadening the scope of the club's activities, she also invited to perform there Sergei Prokofiev, Igor Stravinsky, Martha Graham, Harold Kreutzberg, and Leonid Massine, who made his debut as a soloist for an Arts Club audience.

It was in this atmosphere of artistic profusion and excitement that, at the age of seventy, Joseph Winterbotham conceived a plan for assisting the Art Institute — one of the youngest of America's great art museums — in building its permanent collection of European paintings. In 1890, the museum had purchased a group of Old Masters from the Prince Demidoff Collection, sold that year in Paris, which comprised works by Rembrandt, Ruisdael, Hobbema, and van Ostade. El Greco's masterpiece *The Assumption of the Virgin* had been bought in 1906, a Courbet landscape and Fantin-Latour's famous *Portrait of Edouard Manet* had been acquired, as had the Henry Field Collection of Barbizon pictures by such mid-nineteenth-century French artists as Camille Corot, Jules Breton, and Jean François Millet. Following European precedents, an entire gallery was devoted to plaster-cast copies of classical, medieval, and Renaissance sculptures and architectural fragments, giving midwestern visitors a concept of the roots of Western European art. However, despite the 1913 exhibition of the revolutionary "Armory Show," there was little in the Art Institute to indicate the contemporary art movements that had been underway on the continent since the turn of the century. Although the great French Impressionist and Post-Impressionist paintings, for which the Art Institute has become renowned, had been regularly exhibited, they had not yet been contributed to the museum by Chicago collectors Berthe Potter Palmer, Frederic Clay Bartlett, and Mr. and Mrs. Martin A. Ryerson, who gave them in subsequent

Fig. 3. *Rue Winterbotham Carpenter. Photo courtesy of the Chicago Historical Society.*

years — 1922, 1926, and 1933, respectively. Only two works of twentieth-century art were among the museum's holdings, and both were salon pieces in the previous century's academic tradition.[2]

Joseph Winterbotham did not offer the Art Institute works of art from his own collection — no evidence exists that he even collected art — but, rather, he offered the museum the opportunity to buy paintings that it wanted and needed to broaden the scope of its holdings. His initial 1921 gift was $50,000, which he stated was to be invested and the interest used "for the purchase of works of art painted by European artists of foreign subjects."[3] He designated that the collection of paintings purchased with these funds should eventually number thirty-five, and that no more than $2,500 should be expended on any one. However, once a collection of thirty-five was accumulated, any picture could be replaced by one of

better quality, for a sum greater than $5,000. By making this later stipulation, Winterbotham made clear his intention to insure that "the purchase of paintings, as time goes on, is toward superior works of art and of greater merit and continuous improvement."[4] A letter to Winterbotham from Art Institute president Charles L. Hutchinson reveals the warm reception to his unique and farsighted offer: "The terms of your splendid gift to the Art Institute have been announced to the Board of Trustees, and I am writing to tell you that the gift has been accepted with great enthusiasm.... There can be no doubt that your gift, which makes possible building up of this much needed section of our collection, will have far-reaching value in the development of the museum toward a more adequate and well-balanced representation."[5]

The original terms of the deed of gift gave the responsibility for the selection and purchase of paintings to the trustees or their appointed representatives. The early commitment to buying European art of modernist persuasion was more the result of the individuals upon whom these responsibilities devolved than of a formal indication by Winterbotham. A new director and curator, Robert B. Harshe, was an amateur painter and believed in a strong museum emphasis on European modern art; and trustee Frederic Clay Bartlett, also a painter, traveled widely and, with his wife Helen Birch Bartlett, was forming an extraordinary collection of avant-garde art, which included examples by Picasso, Matisse, Derain, Modigliani, late work by Cézanne, van Gogh, Gauguin, and Toulouse-Lautrec, as well as Seurat's monumental *Sunday Afternoon on the Island of La Grande Jatte*.[6] These two men, along with Charles Hutchinson and Martin Ryerson, eagerly began buying for what would be called the Joseph Winterbotham Collection.

They lost no time in making their first purchase, a Matisse canvas painted in Nice in 1919 and entitled *Woman Standing at the Window* (fig. 5), which not only represented that artist for the first time in the Art Institute, but was among the first works by Matisse in an American museum. Early in 1922, they purchased two works by contemporary German and Austrian artists Max Clarenbach and Julius Paul Junghanns, whose paintings had been shown at the 1914 Carnegie Institute International Exhibition. Although these two paintings and

others acquired during the early years of the collection's formation, did not pass the test of time and were subsequently replaced by finer pictures, it was the special feature of the Winterbotham gift to take such risks. It must have lessened the burden felt by the early executors to know that their purchases were not necessarily irrevocable. They could pick from the current art of the day and bring to the Midwest examples of the most recent European artistic activity. If, in time, their choices proved to be of lesser interest, other pictures of greater significance to the museum's overall collections could take their places. Thus, implicit requirements for constant reevaluation and gradual growth — in quality rather than quantity — were integral parts of the Winterbotham Plan. To provide a complete picture of the collection's changing composition, a chronological

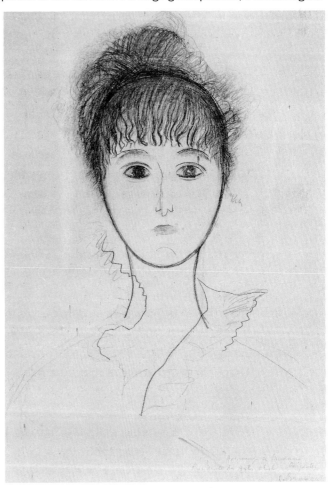

Fig. 4. *Constantin Brancusi*, Portrait of Rue Carpenter, c. 1927, black chalk, 645 × 450 mm. The Art Institute of Chicago, gift of Mrs. Patrick Hill in memory of her mother, Rue Winterbotham Carpenter.

list of all paintings acquired for it is included at the end of this catalogue.

Impatient to see the collection grow, on three occasions Joseph Winterbotham, hearing of impending visits to Europe by Art Institute trustees, sent checks to buy paintings. For one check, given in 1922, he specified that the painting to be purchased "be of superior excellence, of a beautiful land-scape."[7] This charge was dispatched with the acquisition of the Art Institute's first Gauguin, a lyrical landscape of 1892 called *The Burao Tree (Te Burao)* (p. 18). In 1923, the Arts Club, which administered a gallery in the museum between 1922 and 1927, mounted an exhibition of paintings by Jean Louis Forain, from which was purchased one of the artist's charac-teristically insightful works of social commentary, called *Sentenced for Life* (p. 17). During the next few years, an acquisition by Leo Putz, an Austrian colorist living in Munich, and another by Gauguin, the ravishing 1890 *Portrait of a Woman* (p. 19), brought the number of works to seven. Shortly before he died in 1925, Winterbotham experienced the great satisfaction of seeing Toulouse-Lautrec's arresting and unconventional composition of 1888, *In the Circus Fernando: The Ringmaster* (p. 20), added as the collection's eighth picture. Earlier that year, the canvas had been shown in Chicago's first exhibition of paintings by that artist, also organized under the aegis of the Arts Club.

After their father's death, Rue Carpenter and John Winterbotham augmented the principle of his gift to $70,000. Six more paintings were acquired in 1929. Five of them were purchased in Europe by Frederic Clay Bartlett, who wrote back to the director that he had wrangled with the dealers to reduce their prices in order to meet Winterbotham's original $2,500 per-painting terms. "I think we must try very hard to change the terms of the gift, otherwise as things are going, we could never get together a collection worthy of Mr. Winterbotham's aim," he lamented.[8] Nevertheless, he returned to Chicago with a Braque still life (p. 23) and four other pieces by artists he thought quite promising: Jean Lurçat, Charles Dufresne, Jean Marchand, and an Australian-born Frenchman named Edouard Goerg, whose work he liked so well he bought one of his paintings for himself. The final acquisition of the year, André Dunoyer de Segonzac's

Summer Garden (The Hat with the Scottish Ribbon) of 1926 (p. 22), had been initially purchased by Rue Carpenter and then was bought by the museum for the Winterbotham Collection, bringing the number of works to a total of fifteen at the close of the decade. Of these, six — the Forain, the two Gauguins, the Toulouse-Lautrec, the Braque, and the Segonzac — have been of such enduring significance and value that they are still part of the collection and mark an extraordinary period of vitality and experimentation, both by European artists and by the Art Institute.

In 1935, Joseph Winterbotham, Jr. (fig. 6) suggested that the composition of the Winterbotham Committee be changed to include the active participation of a family member, along with the museum director and a trustee. Highly qualified to represent the family, this younger son of the original benefactor had formed his own worthy collection of European and Oriental art. In fact, the Arts Club opened its

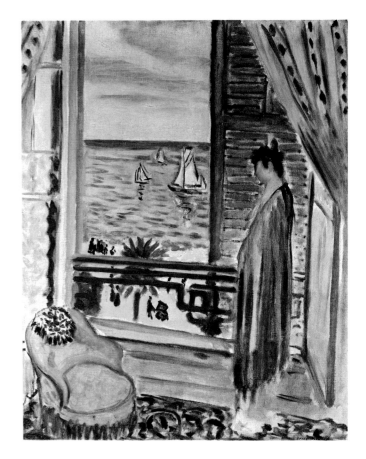

Fig. 5. *Henri Matisse,* Woman Standing at the Window, *1919. Private collection.*

new quarters in the Wrigley Building in 1936 with an exhibition of paintings and drawings from his collection. At the time the younger Winterbotham assumed a position on the Winterbotham Committee, he also proposed an amendment to the 1921 deed of gift that formalized an emphasis on contemporary art, stating: "No picture is to be purchased for the Winterbotham Collection executed by an artist who has been dead over ten years – only foreign, contemporary, living artists' work to be purchased."[9]

During the 1930s, because of the worsening political situation in Europe, trips there began to be less frequent. Chaim Soutine's 1929 canvas *Small Town Square, Vence* (p. 25) was bought in Paris in 1931, but, soon after, the Winterbotham Committee began to look to the New York galleries, which were representing more and more European artists, many whose work had been banned by the Nazis. Soon after it was constituted, the new committee bought pictures by Dufy (p. 24), Derain, Hofer, Matisse (p. 26), Modigliani (p. 30), another by Soutine (p. 28), and a third version of Marc Chagall's *Praying Jew (Rabbi of Vitebsk),* painted in 1923 and exhibited at New York's Museum of Modern Art in 1932 (p. 29). Joseph Winterbotham, Jr. donated the collection's first Surrealist example, a mysterious canvas by Salvador Dali entitled *Shades of Night Descending,* which was later traded for Dali's *Inventions of the Monsters* of 1937 (p. 34). With the help of the committee, Daniel Catton Rich, the Art Institute's Curator of Painting and Director of Fine Arts from 1938 to 1958, engineered a number of remarkable purchases for the collection: Giorgio de Chirico's haunting early canvas *The Philosopher's Conquest* of 1914 (p. 32); Oskar Kokoschka's color-saturated 1919 landscape *Elbe River Near Dresden* (p. 31), which had been confiscated in Austria, but was smuggled out of the country to a New York art dealer; and Picasso's Cubist *Head of a Woman* of 1909 (p. 33), formerly among Gertrude Stein's famed collection of early twentieth-century art. The committee decided to loosen the restriction on purchases of only European art after several exhibitions in the United States of the exciting work of Mexican muralists and painters José Clemente Orozco, Rufino Tamayo, and Diego Rivera. During the 1940s, paintings by each of these artists were acquired, with Rivera's

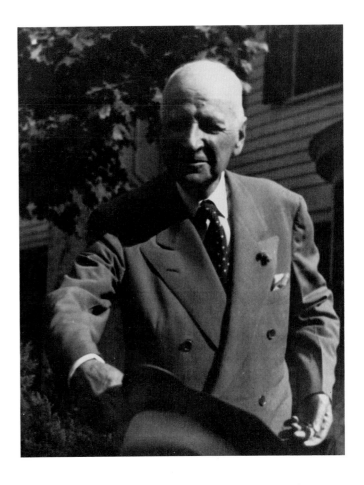

Fig. 6. *Joseph Winterbotham, Jr., late 1940s. Photo courtesy of the Winterbotham family.*

Mother Mexico of 1935 coming as a gift from Joseph Winterbotham, Jr. In deference to the collection's original conception, these pictures were replaced many years later by works of European artists. In 1946, with the purchase of Yves Tanguy's Surrealist landscape *The Rapidity of Sleep* (p. 35), painted the previous year, the Joseph Winterbotham Collection finally achieved its designated goal of thirty-five paintings.

The complete Joseph Winterbotham Collection was shown together as a group for the first time in 1947 (see fig. 7) in a special month-long exhibition accompanied by an illustrated catalogue written by Katharine Kuh, who would shortly become the Art Institute's Curator of Modern Painting and Sculpture. One of Joseph Winterbotham's original stipulations had indicated that, once the collection was complete, a room should be equipped for its permanent

installation. In 1945, his son modified this directive to require only an annual showing of the group.[10] During the rest of the year, each painting was placed where the museum deemed it could be shown to best advantage, amidst other work of its type or period. Every year, for many years, the collection was mounted together at regular intervals. On one occasion in 1949, a selection of twenty-four paintings was requested by the Dallas Museum of Fine Arts for exhibition at the Texas State Fair, under the title "The Joseph Winterbotham Collection of Twentieth-Century European Paintings." The paintings have never again traveled together as a group, in part because they are integrated within and central to the museum's collection of late nineteenth- and twentieth-century art, and their absence would be keenly felt.

The time had now arrived when, according to the deed of gift, exchanges and replacements in the collection could be made with the objective of improvement. As mentioned earlier, the elder Winterbotham foresaw the necessity of providing more money for this purpose and required that each replacement cost no less than $5,000. An astute businessman, he seems to have anticipated the upward spiral of the art market. The first opportunity to make an exchange came in 1949, when Joseph Winterbotham, Jr. offered to sell to the Art Institute, for a modest sum, one of the centerpiece's of his own collection, El Greco's *Feast in the House of Simon* of c. 1610/14 (p. 37). In making this generous offer, Winterbotham, Jr. rescinded his earlier amendment requiring the purchase of only contemporary art and proposed a return to his father's broader stipulation.[11] Thus began an era of major contributions to the collection by the Winterbotham family, replacing lesser quality pictures purchased in the 1920s and '30s. Fernand Léger's *Follow the Arrow* of 1919 (p. 38), originally purchased by Rue Carpenter, was given in her memory by her daughter Mrs. Patrick Hill in 1953. Also, in 1953, the Art Institute acquired van Gogh's *The Drinkers* of 1890 (p. 40) from Winterbotham, Jr., and accepted his gift of Cézanne's *Apples on a Tablecloth* of c. 1886/90 (p. 39); when he died at age seventy-six, in 1954, he bequeathed the major portion of his private collection of European and Oriental art to the Art Institute. A total of eight works were eventually accessioned into the Collection.

Rue Winterbotham Shaw (fig. 8), granddaughter of the elder Joseph Winterbotham, had assumed the mantle of her aunt Rue Carpenter as president of the Arts Club in 1940, and she was the natural heir to her uncle's position on the Winterbotham Committee. In both realms, she provided firm and perspicacious leadership. She had studied painting with Walt Kuhn in New York and with Nathalie Gontcharova in Paris, settling in Chicago with her husband Alfred Phillips Shaw, a prominent architect, and following in the art activist footsteps of her predecessors. For thirty-nine years (1940-79), as president of the Arts Club, she directed a program of exhibitions, lectures, and concerts that assured and maintained the club's international reputation. A tireless defender of the avant-garde, she brought to Chicago its first exhibitions of work by Ernst, Hofmann, Lipchitz, Lam, Davies, Pollock, Noguchi, Motherwell — only a few in a lengthy list of adventurous shows. She counted among her close friends many great artists, composers, and authors in both the United States and Europe, including Marianne Moore, Virgil

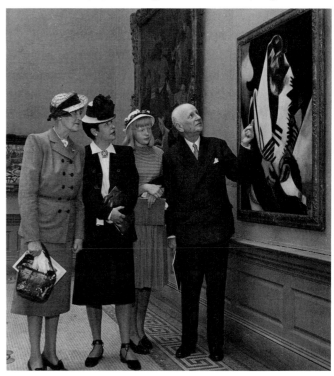

Fig. 7. *Left to right: Mrs. Joseph Winterbotham, Jr., Mrs. Rue Winterbotham Shaw, Miss Rue Diana Hill, and Joseph Winterbotham, Jr. at the first exhibition of the Joseph Winterbotham Collection at The Art Institute of Chicago, 1947. Photo courtesy of The Art Institute of Chicago archives.*

Thompson, and Alexander Calder. One of Calder's finest mobiles, commissioned by her in the early 1940s, still can be seen in the Arts Club foyer. When the club moved to its present day location in 1951, members could boast of an interior designed by Ludwig Mies van der Rohe. Rue Shaw had persuaded the great architect of the International Style, who was teaching in Chicago at the Illinois Institute of Technology, to donate his services. The club's modernist elegance reflected the taste, gentility, and integrity that Rue Shaw brought to her work, earning her the reputation as the most esteemed and influential member of the Chicago art community.

At the time Rue Shaw began to represent the family on the Art Institute's Winterbotham Committee, the collection was taking a direction quite different from one that emphasized contemporary European art. Along with other committee members — Daniel Catton Rich, trustee Leigh Block, and Katherine Kuh — Mrs. Shaw believed the collection would be enhanced by adding to it some of the predominantly nineteenth-century paintings included in her uncle's bequest. The first group of additions was composed of Cézanne's *House on a River* of 1885/90 (p. 42), van Gogh's masterful *Self-Portrait* of c. 1886/87 (p. 41), Odilon Redon's luminous *Evocation* of c. 1905/10 (p. 43), and a canvas thought to be by Gauguin called *Of Human Misery*. Four other pictures from Joseph Winterbotham, Jr.'s bequest were brought into the collection several years later; these included an undated pastel by Matisse called *A Dancer in Red;* Degas's *Portrait After a Costume Ball* of 1877/79 (p. 48); a landscape by a student of Courbet named Marcel Ordinaire, which was thought to be by the master; and a portrait of c. 1879 by Edouard Manet called *Young Woman* (p. 50). The complexion of the Winterbotham Collection thus began to appear as one featuring key artists and styles in the history of modern art. To further develop this new direction, Katharine Kuh was able to find and propose the purchase of three important paintings by early twentieth-century pioneers: Kokoschka's 1908 *Portrait of Ebenstein* (p. 45); Miró's 1918 *Portrait of a Woman (Juanita Obrador)* (p. 44); and Robert Delaunay's 1911 *Champs de Mars (The Red Tower)* (p. 47). A. James Speyer, who succeeded Kuh as Curator of Twentieth-Century

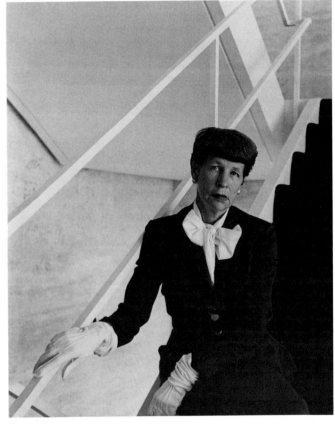

Fig. 8. *Rue Winterbotham Shaw on the stairs of the Arts Club, 109 E. Ontario St., Chicago, designed by Mies van der Rohe, 1951. Photo courtesy of the Winterbotham family.*

Painting and Sculpture and as a Winterbotham Committee member in 1961, continued to look for paintings that would highlight the major accomplishments of twentieth-century art. In the ensuing years, Speyer suggested the purchase of Ben Nicholson's *November, 1956 (Pistoia)* of 1956 (p. 49); Balthus's *Patience* of 1943 (p. 51); Dubuffet's *Genuflexion of the Bishop* of 1963 (p. 52); and, in 1970, the last picture bought to date for the collection, Rene Magritte's *Time Transfixed* of 1938 (cover and p.55). One more addition was made in 1973, when the committee included in the thirty-five a painting by Claude Monet, *Etretat* of 1883 (p. 56), that had been given earlier to the Art Institute by Rue Shaw's mother, Mrs. John H. Winterbotham.

In its sixty-five year history, the Joseph Winterbotham Collection has taken various configurations, each attempting to fulfill the objective of its creator to give the Art Institute a

group of European paintings of the highest quality. So astute were many of the early choices that eighteen of the original group of thirty-five paintings remain in the collection.[12] Guided by the capable hands and unfailing generosity of succeeding generations of the Winterbotham family, the Joseph Winterbotham Collection now contains some of the signal works in the museum's permanent holdings of nineteenth- and twentieth-century art. Yet, according to the terms of this farsighted gift, the current composition of the collection is not immutable. It will continue to be reassessed on a regular basis and, undoubtedly, opportunities will arise to make advantageous exchanges. There seems to be little question that the collection's future will be just as it was envisioned by its founder; and because of that vision, visitors to the Art Institute will continue to see increasingly outstanding examples of European art.

NOTES

1. Quoted in Emmett Dedmon, *Fabulous Chicago* (New York, 1953)

2. These were: *Two Sisters, Valencia,* 1909, by Joaquin Sorolla y Bastida (Spanish, 1863-1923), and *Woman in Gray,* 1908, by Sir William Orpen (British, 1878-1931).

3. Joseph Winterbotham Deed of Gift to The Art Institute of Chicago, Apr. 9, 1921. The Art Institute of Chicago archives.

4. Ibid.

5. Charles L. Hutchinson to Joseph Winterbotham, Apr. 18, 1921. The Art Institute of Chicago archives.

6. For a discussion of Frederic Clay Bartlett and the Helen Birch Bartlett Memorial Collection, given to the Art Institute in 1926, see The Art Institute of Chicago, *Museum Studies* 12, 2 (Spring 1986), which is entirely devoted to this collection.

7. Joseph Winterbotham to Charles L. Hutchinson, June 8, 1922. The Art Institute of Chicago archives.

8. Frederic Clay Bartlett to Robert B. Harshe, June 5, 1929. The Art Institute of Chicago archives.

9. Joseph Winterbotham, Jr. modification to Deed of Gift, Nov. 25, 1935. The Art Institute of Chicago archives.

10. Joseph Winterbotham, Jr. to Chauncey McCormick, Mar. 17, 1945. The Art Institute of Chicago archives.

11. Joseph Winterbotham, Jr. to Chauncey McCormick, Sept. 27, 1949. The Art Institute of Chicago archives.

12. Forain's *Sentenced for Life*, Gauguin's *The Burao Tree* and *Portrait of a Woman*, Lautrec's *In the Circus Fernando*, Braque's *Still Life*, Segonzac's *Summer Garden*, Dufy's *Villerville* and *Open Window, Nice*, Soutine's *Small Town, Vence* and *Dead Fowl*, Matisse's *Still Life with Geranium Plant and Fruit*, Chagall's *Praying Jew,* Modigliani's *Madam Pompadour,* de Chirico's *Philosopher's Conquest*, Kokoschka's *Elbe River Near Dresden*, Picasso's *Head of a Woman*, Dali's *Inventions of the Monsters*, and Tanguy's *Rapidity of Sleep*.

THE JOSEPH WINTERBOTHAM COLLECTION

PLATES

Editor's note: The following works of art are arranged in chronological order, according to the date of their acceptance into the collection. Dimensions are given in centimeters: height precedes width.

JEAN LOUIS FORAIN *Sentenced for Life,* c. 1910, oil on canvas, 65.4 × 81 cm. Acquired 1923.

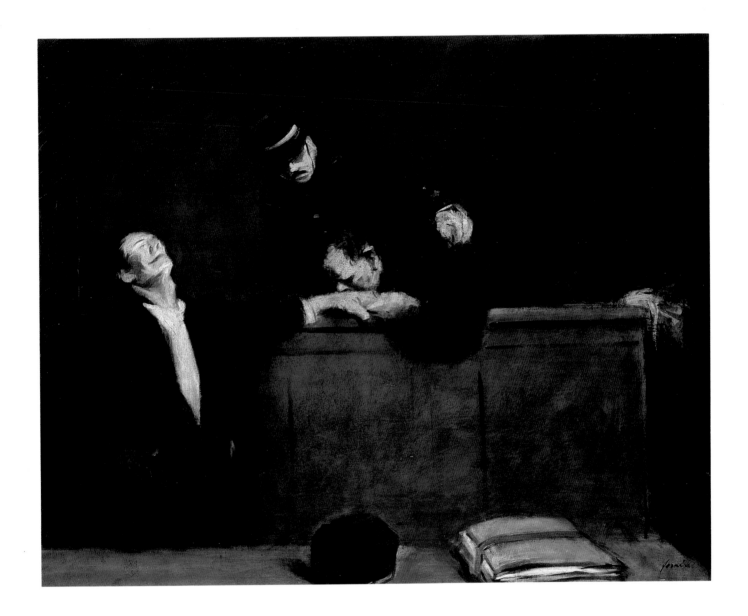

PAUL GAUGUIN *The Burao Tree (Te Burao),* 1892, oil on canvas, 68 × 90.7 cm. Acquired 1923.

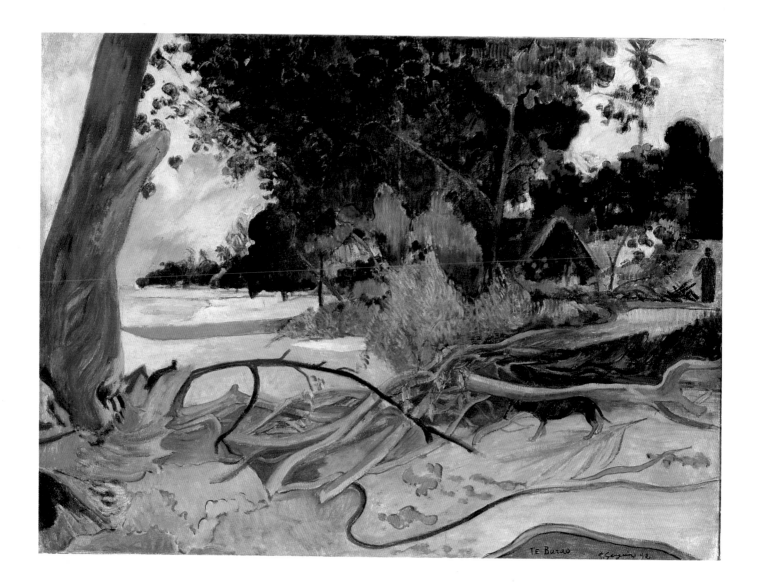

PAUL GAUGUIN *Portrait of a Woman in Front of a Still Life by Cézanne (Marie Derrien)*, 1890, oil on canvas, 65.3 × 54.9 cm. Acquired 1925.

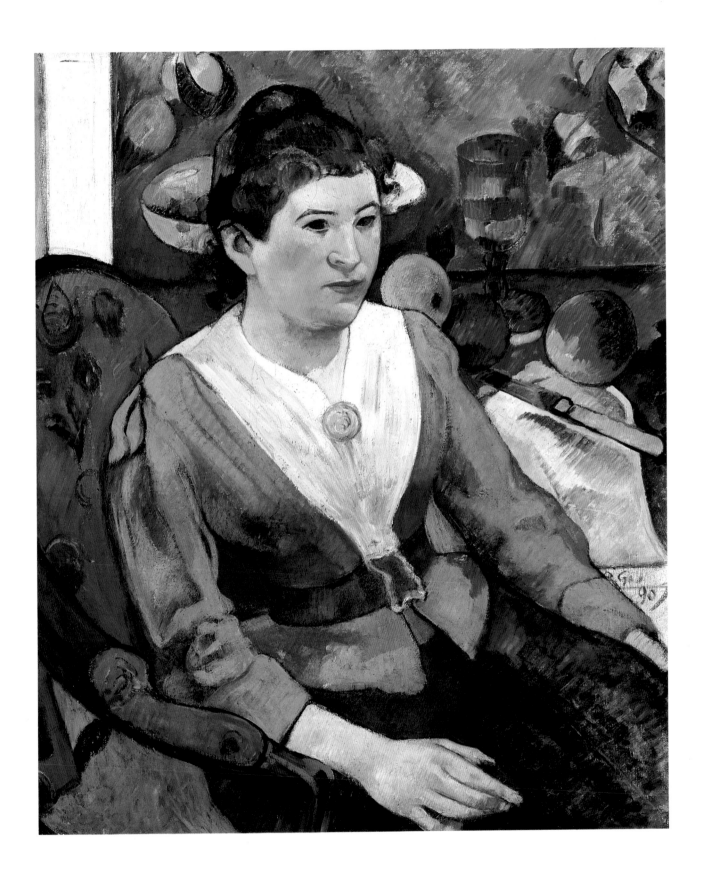

HENRI DE TOULOUSE-LAUTREC *In the Circus Fernando: The Ringmaster,* 1888, oil on canvas, 100.3 × 161.3 cm. Acquired 1925.

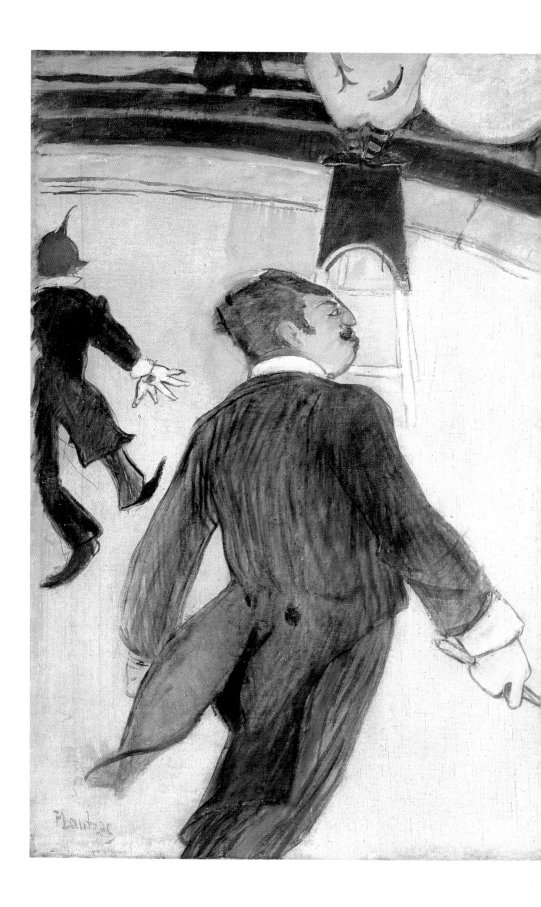

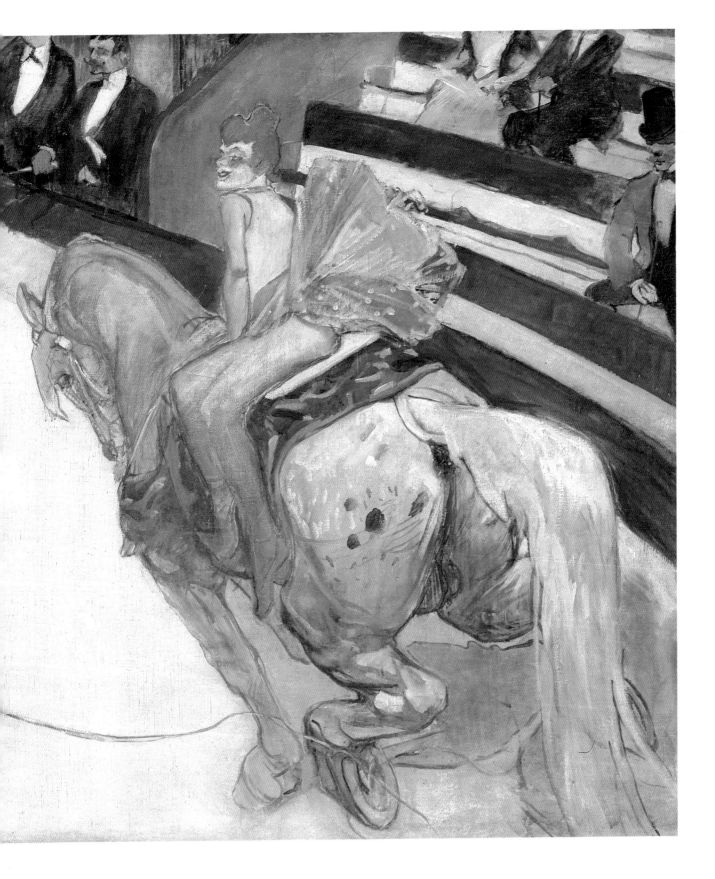

ANDRE DUNOYER DE SEGONZAC *Summer Garden (The Hat with the Scottish Ribbon),* 1926,
oil on canvas, 50.5 × 110.2 cm. Acquired 1929.

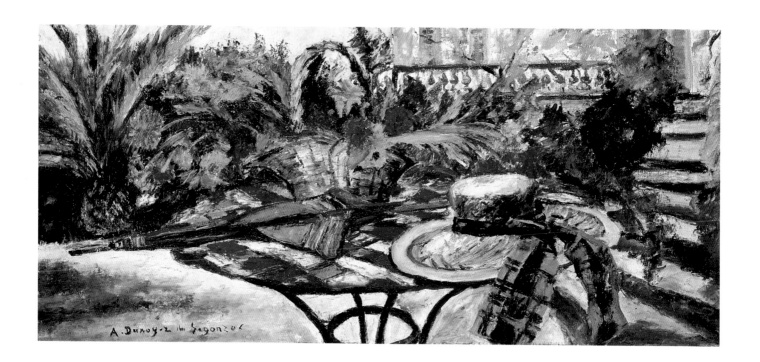

GEORGES BRAQUE *Still Life (Guitar, Fruitbowl, Music Score)*, oil on canvas, 50.2 × 92.2 cm. Acquired 1929.

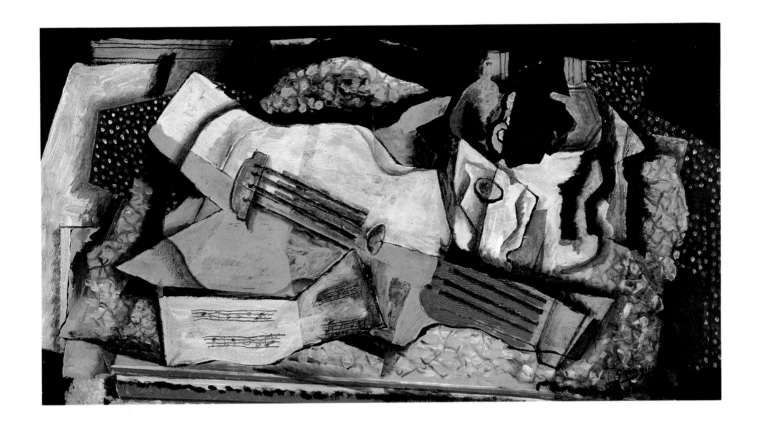

RAOUL DUFY *Villerville*, c. 1928, oil on canvas, 75.6 × 94.8 cm. Acquired 1931.

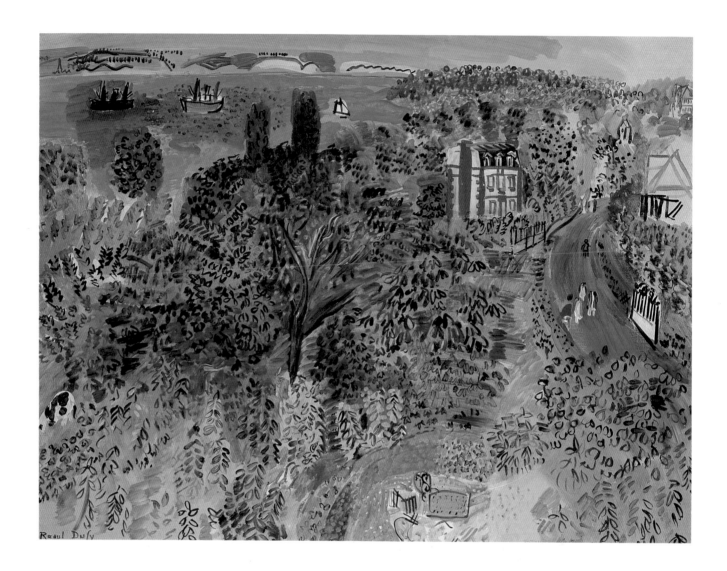

CHAIM SOUTINE *Small Town Square, Vence,* 1929, oil on canvas, 71.4 × 45.7 cm. Acquired 1931.

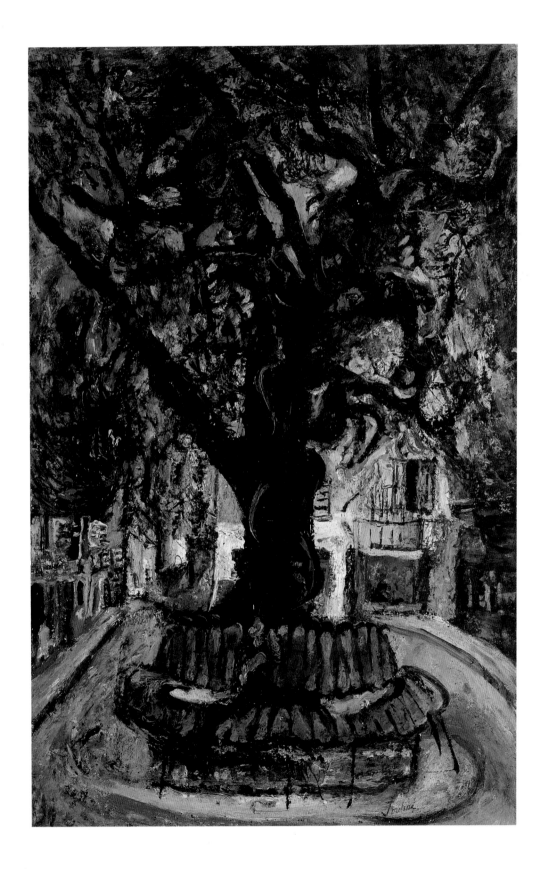

HENRI MATISSE *Still Life with Geranium Plant and Fruit,* 1906, oil on canvas, 101.3 × 82.6 cm. Acquired 1932.

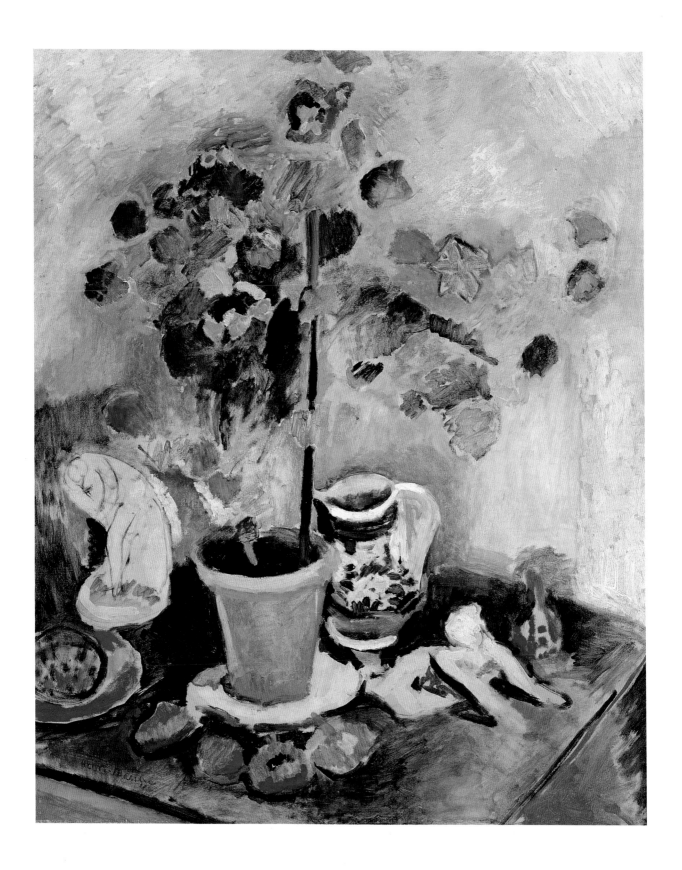

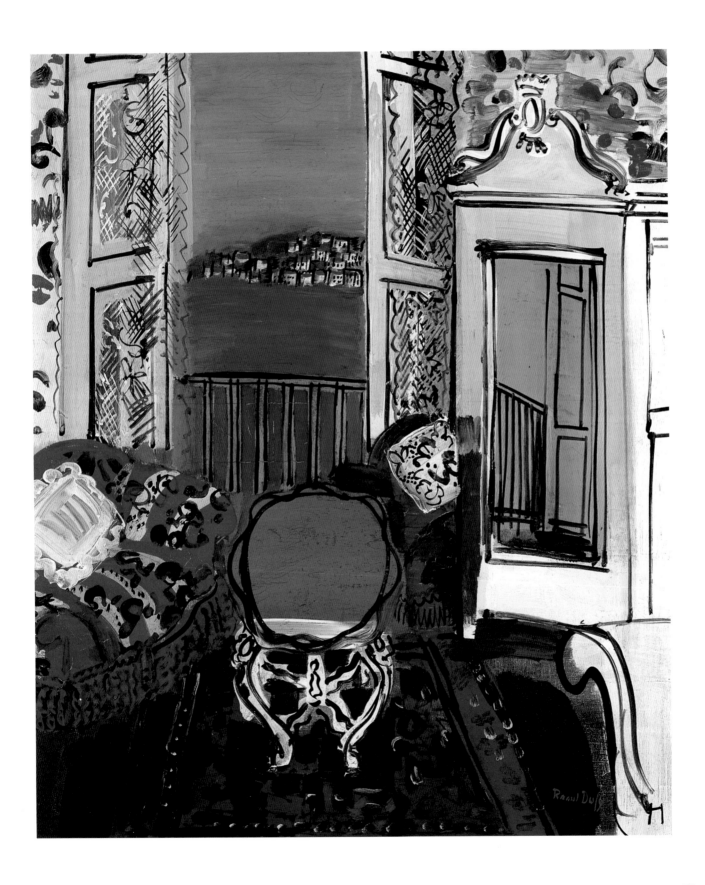

Dead Fowl, c. 1926, oil on canvas, 95.9 × 61.6 cm. Acquired 1937.

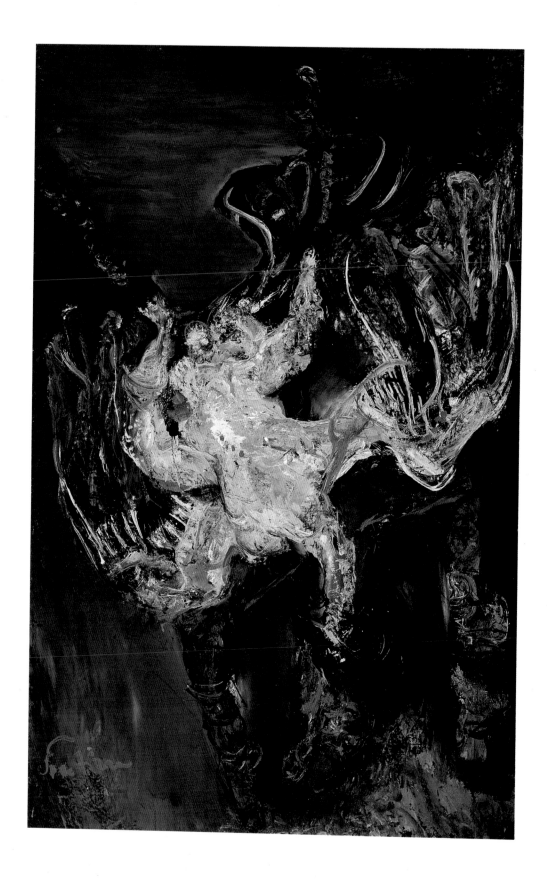

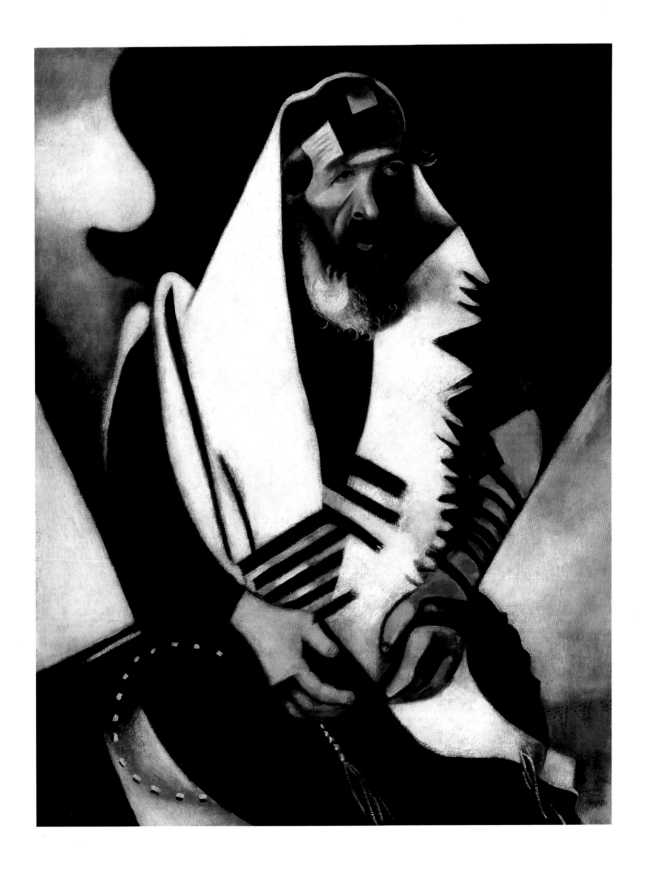

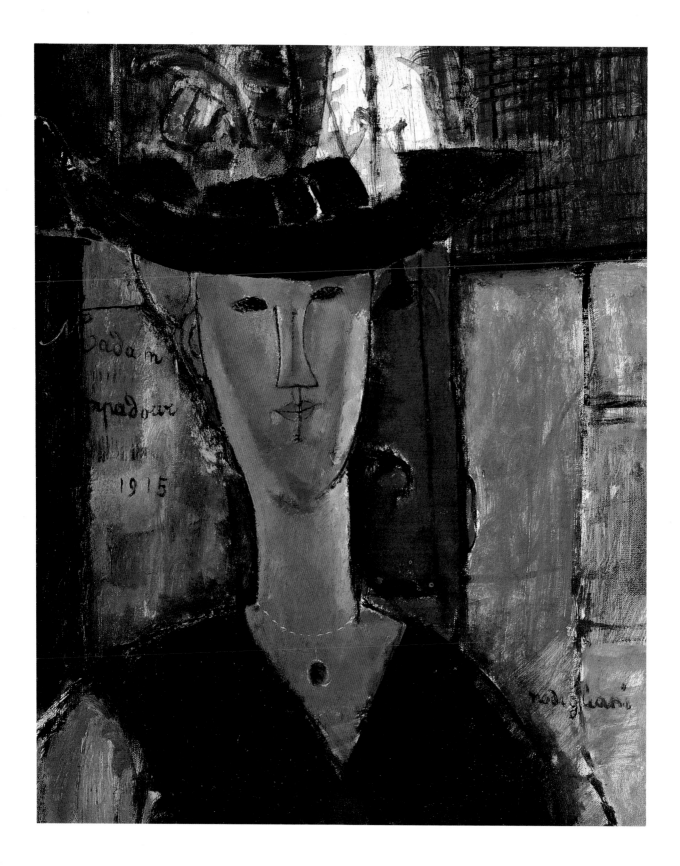

OSKAR KOKOSCHKA *Elbe River Near Dresden,* 1919, oil on canvas, 81.4 × 112.2 cm. Acquired 1939.

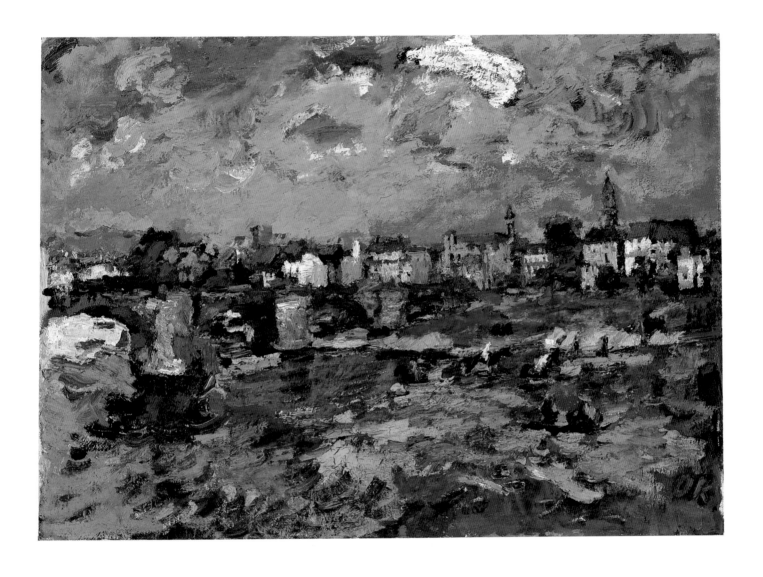

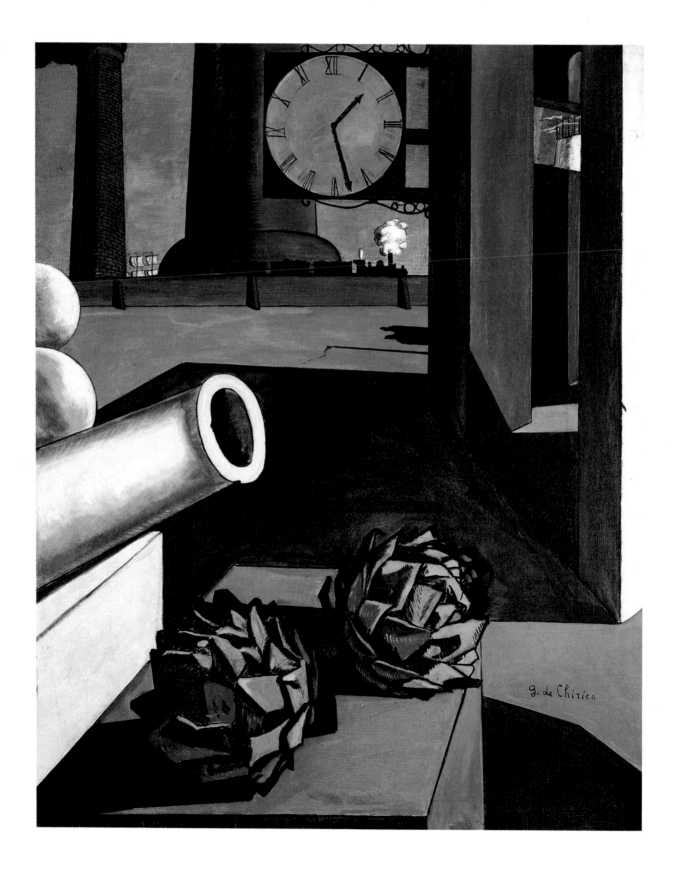

PABLO PICASSO *Head of a Woman,* 1909, oil on canvas, 60.6 × 51.3 cm. Acquired in 1940.

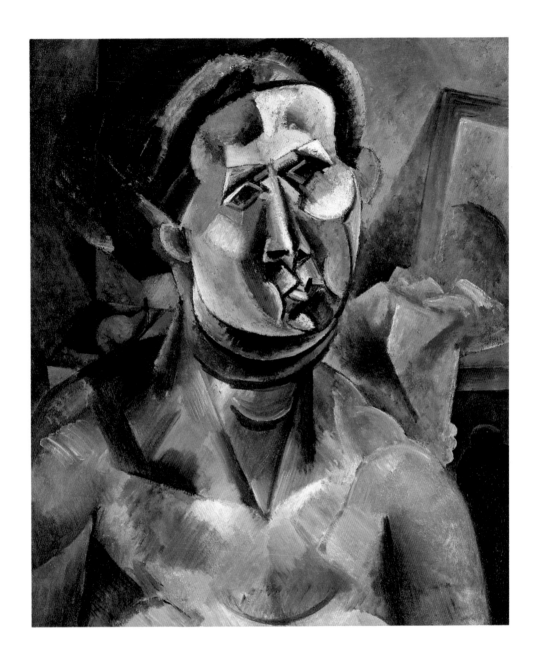

SALVADOR DALI *Inventions of the Monsters,* 1937, oil on canvas, 51.4 × 78.1 cm. Acquired 1943.

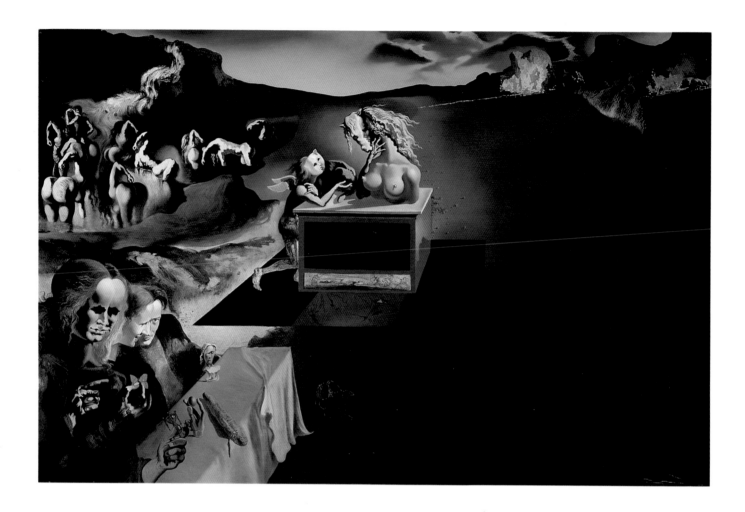

Y V E S T A N G U Y *The Rapidity of Sleep,* 1945, oil on canvas, 127 × 101.6 cm. Acquired 1946.

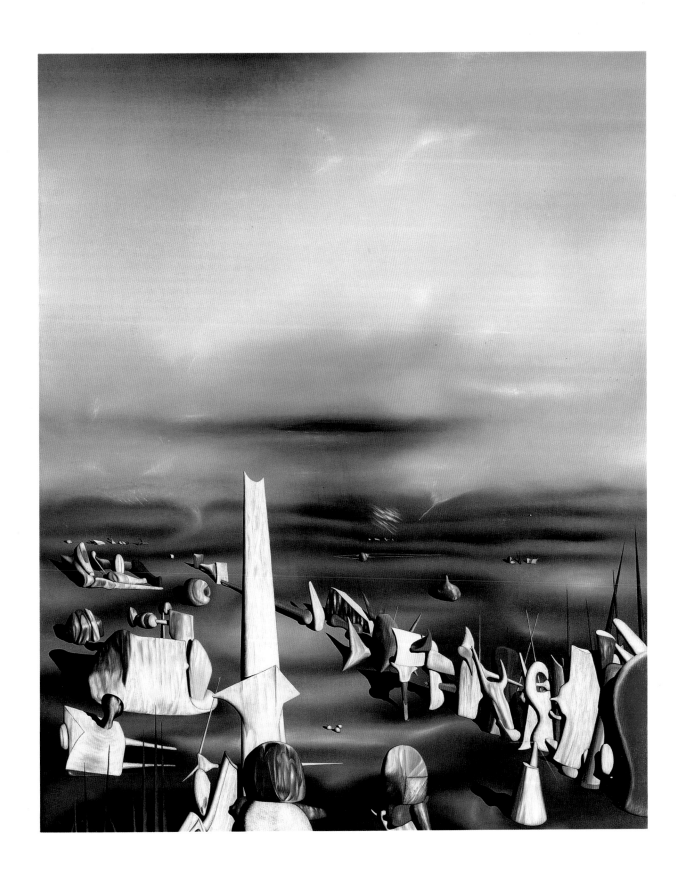

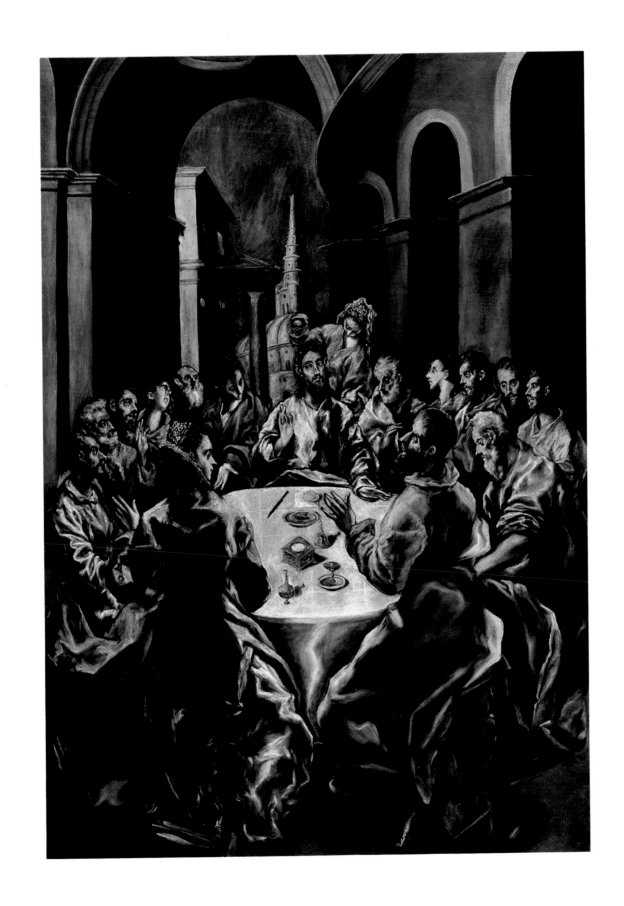

FERNAND LEGER *Follow the Arrow,* 1919, oil on canvas, 54.1 × 65.7 cm. Acquired 1953.

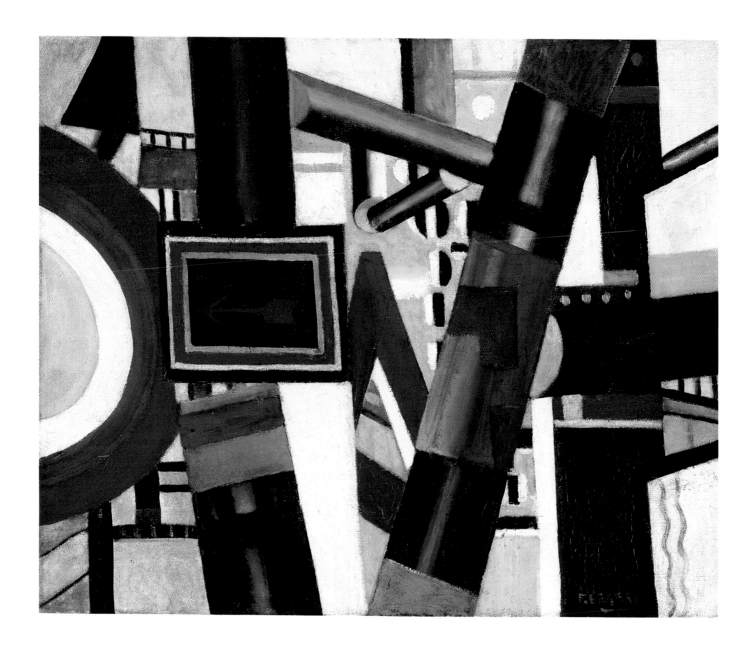

PAUL CEZANNE *Apples on a Tablecloth,* c. 1886/90, oil on canvas, 38.5 × 46.5 cm. Acquired 1953.

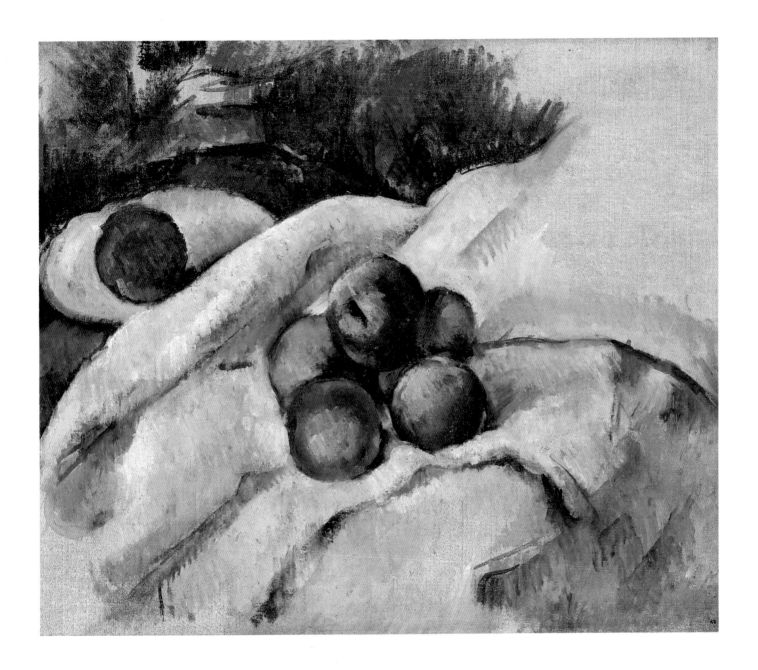

VINCENT VAN GOGH *The Drinkers,* 1890, oil on canvas, 59.4 × 73.4 cm. Acquired 1953.

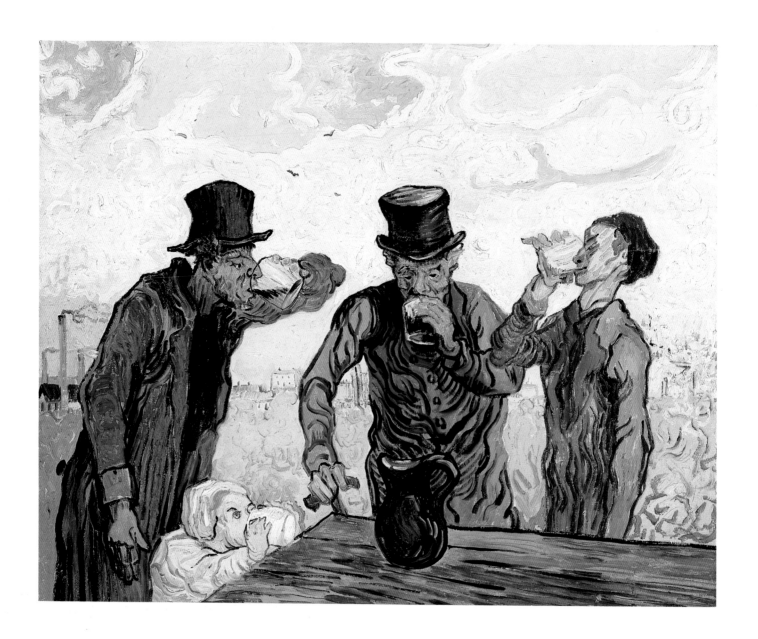

VINCENT VAN GOGH *Self-Portrait*, c. 1886/87, oil on canvas, 41 × 32.5 cm. Acquired 1956.

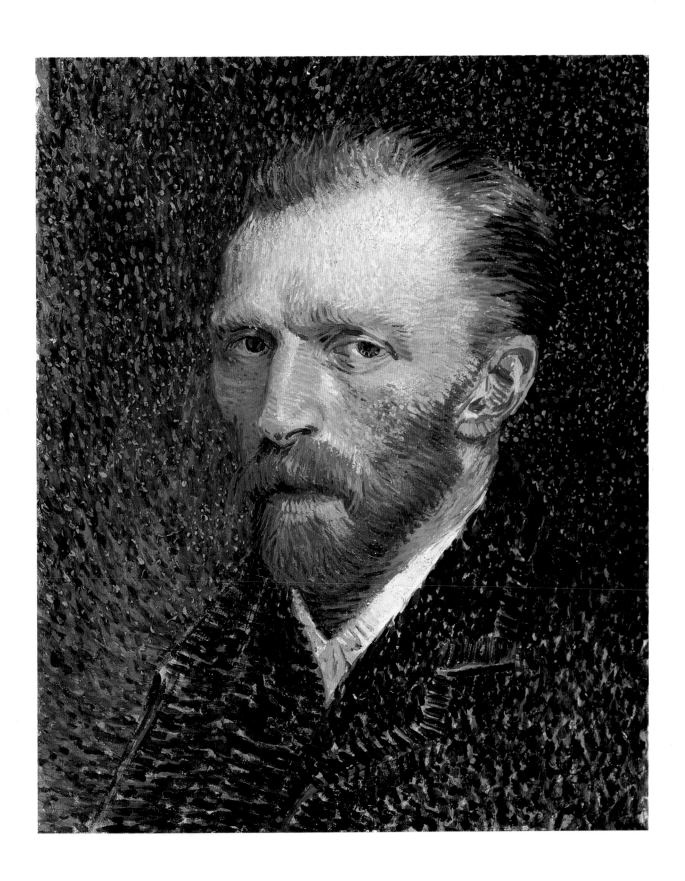

PAUL CEZANNE *House on the River,* 1885/90, oil on canvas, 51.5 × 61 cm. Acquired 1956.

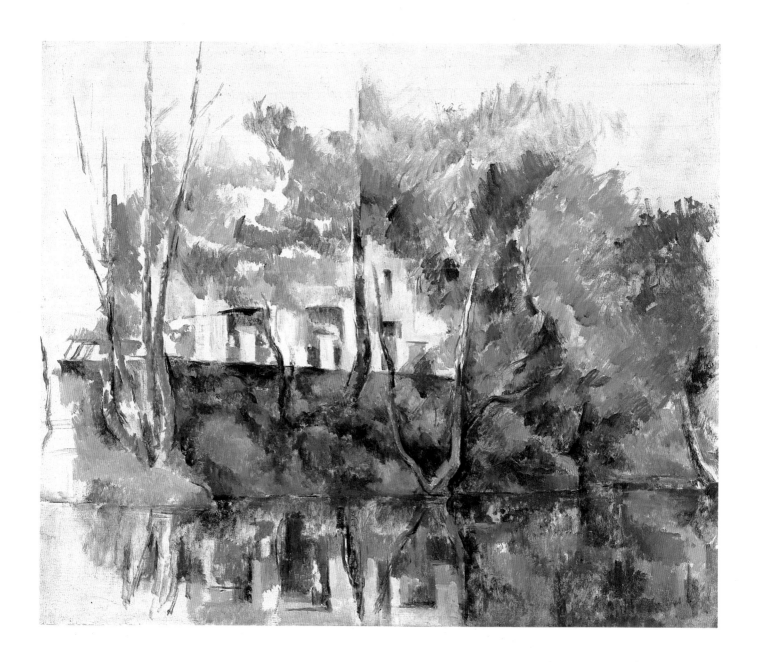

O D I L O N R E D O N *Evocation,* c. 1905/10, pastel on paper, 52.1 × 36.3 cm. Acquired 1956.

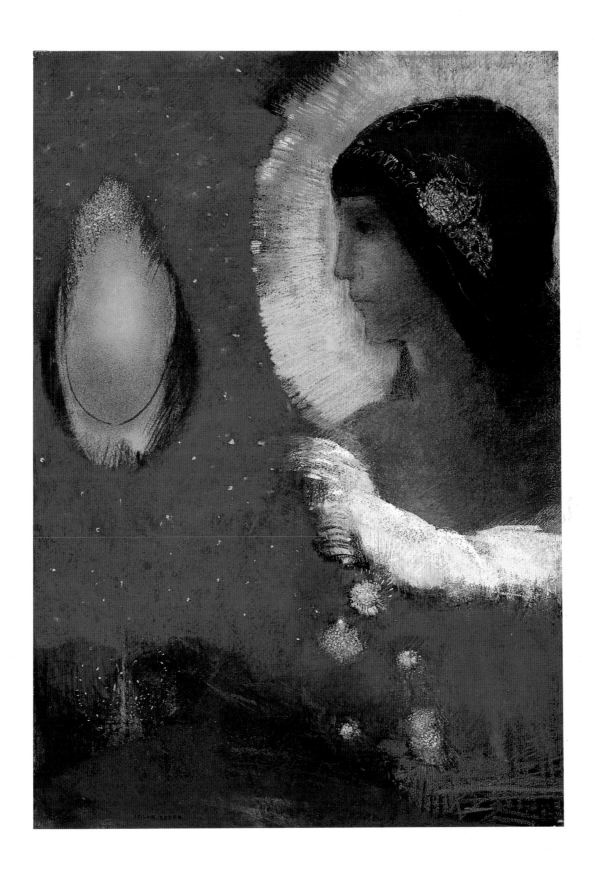

Portrait of a Woman (Juanita Obrador), 1918, oil on canvas, 69.5 × 62 cm. Acquired 1957.

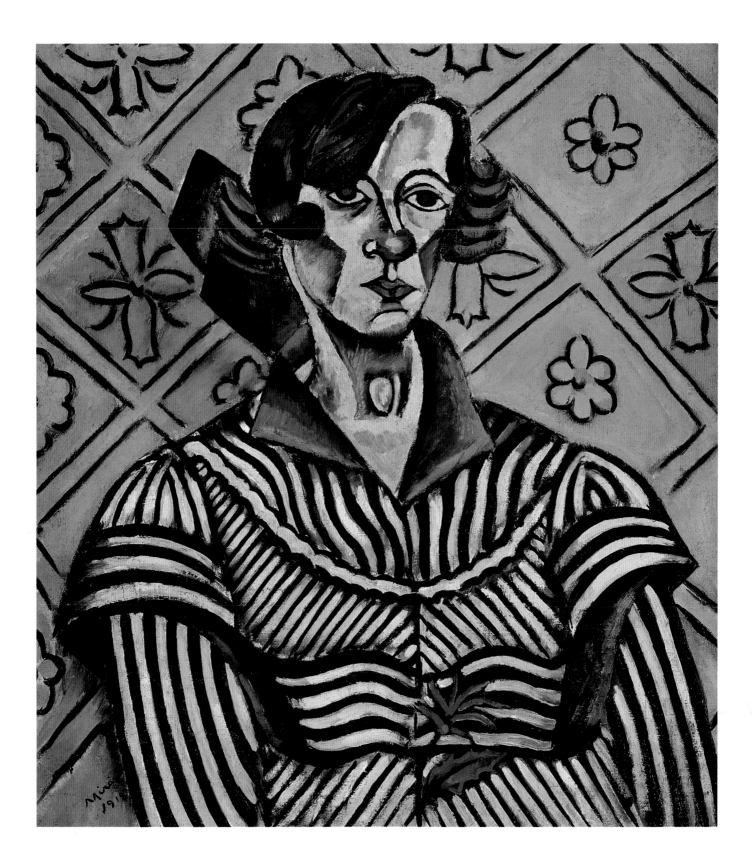

OSKAR KOKOSCHKA *Portrait of Ebenstein,* 1908, oil on canvas, 101.8 × 81.1 cm. Acquired 1956.

ROBERT DELAUNAY *Champs de Mars (The Red Tower),* 1911, oil on canvas, 160.7 × 128.6 cm. Acquired 1959.

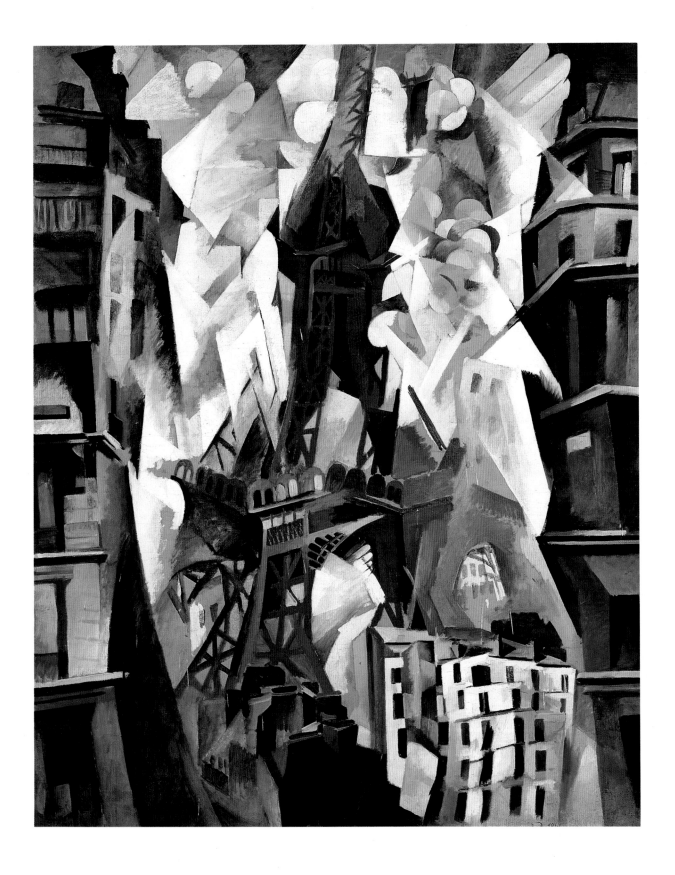

E D G A R D E G A S *Portrait After a Costume Ball (Mme. Dietz-Monin),* 1877/79, gouache, charcoal, pastel, metallic paint, and oil on canvas, 85.5 × 75 cm. Acquired 1961.

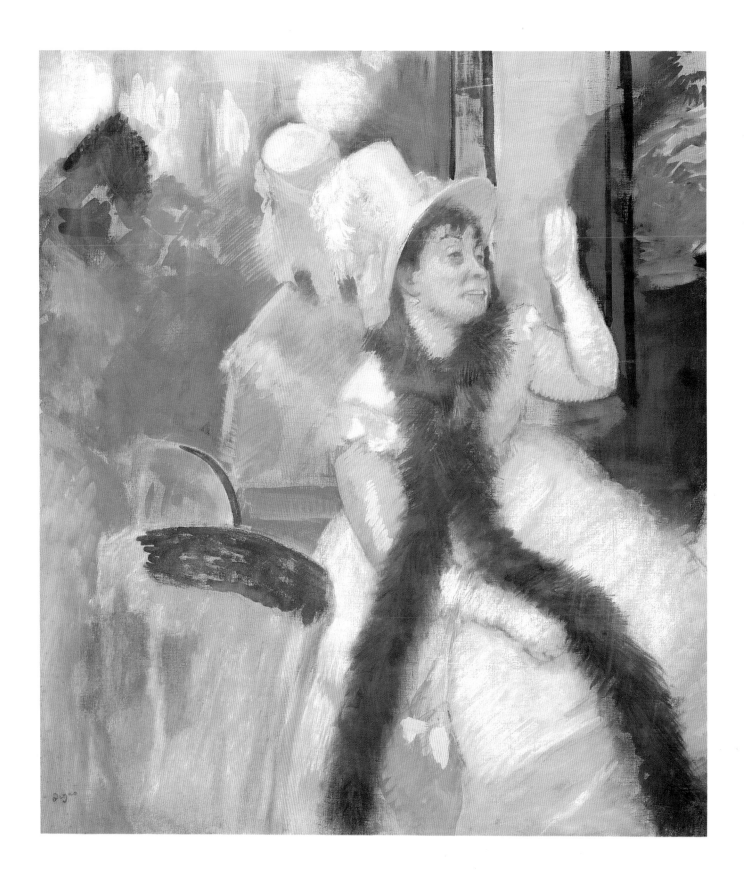

BEN NICHOLSON *November, 1956 (Pistoia),* 1956, oil on canvas, 120 × 212.1 cm. Acquired 1962.

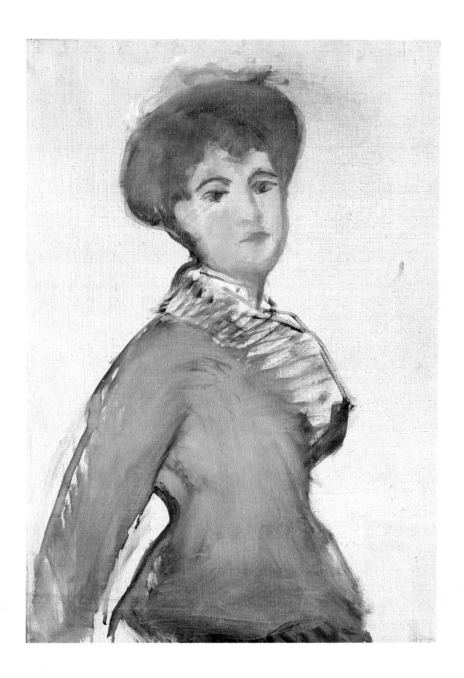

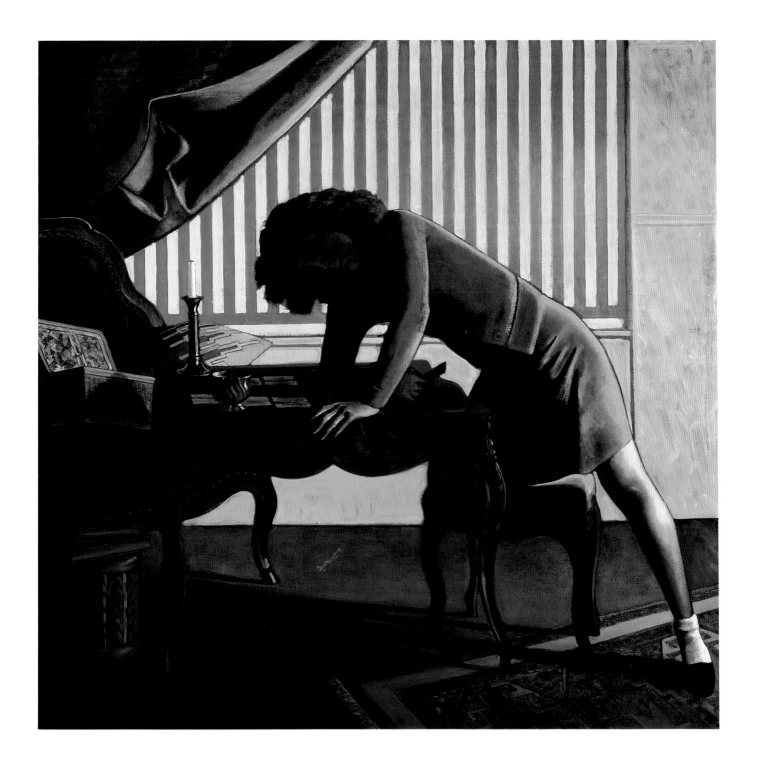

JEAN DUBUFFET *Genuflexion of the Bishop,* 1963, oil on canvas, 217.8 × 298.5 cm. Acquired 1964.

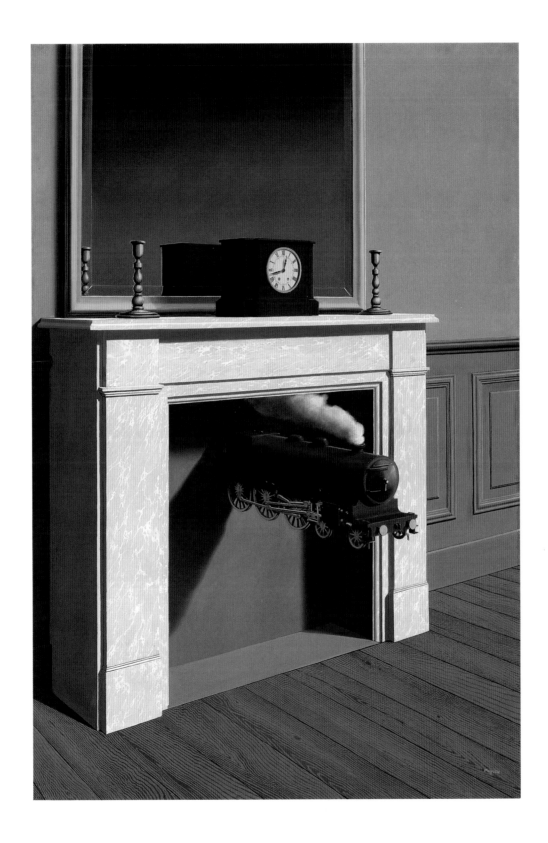

C L A U D E M O N E T *Etretat,* 1883, oil on canvas, 69.3 × 66.1 cm. Acquired 1973.

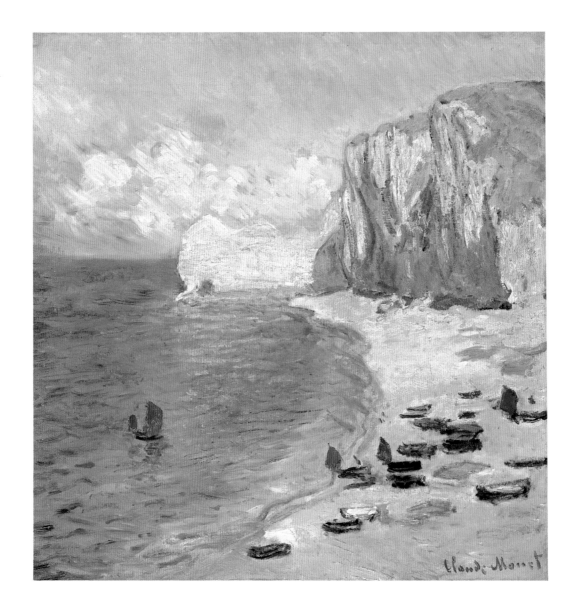

CHECKLIST OF THE COLLECTION 1921-86

Editor's note: * denotes paintings that have been transferred to the Art Institute's general collection and remain in the museum as gifts of the Joseph Winterbotham Collection.

Artist	Title/Date	Acquired	Disposition
Henri Matisse (French, 1869-1954)	*Woman Standing at the Window* 1919	1921	Sold, 1958
Max Clarenbach (German, 1880-1952)	*The Garden,* c. 1914	1922	Sold, 1948
Julius Paul Junghanns (Austrian, 1876-1953)	*Memories from the Tyrol,* c. 1914	1922	Withdrawn, 1955 Sold, 1957
Jean Louis Forain (French, 1852-1931)	*Sentenced for Life,* c. 1910	1923	(p. 17)
Paul Gauguin (French, 1848-1903)	*The Burao Tree (Te Burao),* 1892	1923	(p. 18)
Leo Putz (Austrian, 1869-1940)	*On the Shore,* 1909	1923	Withdrawn, 1955 ·Sold, 1957
Albert Besnard (French, 1849-1934)	**By the Lake,* 1923	1924	Replaced by Gauguin's *Portrait of a Woman* in 1925
Paul Gauguin	*Portrait of a Woman,* 1890	1925	(p. 19)
Henri de Toulouse-Lautrec (French, 1864-1901)	*In the Circus Fernando: The Ringmaster, 1888*	1925	(p. 20)
Emile Othon Friesz, (French, 1879-1949)	*Port of Toulon,* late 1920s	1928	Replaced by Manet's *Young Woman* in 1963 Sold, 1971
Jean Hippolyte Marchand (French, 1883-1941)	*The Garden,* 1920	1929	Withdrawn, 1956 Sold, 1971
Georges Braque (French, 1882-1963)	*Still Life (Guitar, Fruitbowl, Music Score),* 1919	1929	(p.23)
Charles Georges Dufresne (French, 1876-1938)	*Still Life with Compote,* late 1920s	1929	Withdrawn, 1959 Sold, 1971
Edouard Goerg (French, b. Australia, 1893-1969)	**The Epicure,* 1923	1929	Replaced by Ordinaire's *Landscape* in 1963

Artist	Title/Date	Acquired	Disposition
Jean Lurçat (French, 1892-1966)	*Delphi,* c. 1928	1929	Replaced by Delaunay's *Champs de Mars* in 1959 Sold, 1971
André Dunoyer de Segonzac (French, 1884-1974)	*Summer Garden (The Hat with the Scottish Ribbon),* 1926	1929	(p. 22)
Raoul Dufy (French, 1877-1953)	*Villerville,* c. 1928	1931	(p. 24)
Chaim Soutine (Russian, 1893-1943)	*Small Town Square, Vence,* 1929	1931	(p. 25)
Henri Matisse	*Still Life with Geranium Plant and Fruit,* 1906	1932	(p. 26)
André Derain (French, 1880-1954)	*Mme. Catherine Hessling,* 1921	1936	Traded for Kokoschka's *Portrait of Ebenstein* in 1956
Karl Hofer (German, 1878-1955)	**Girls Throwing Flowers,* 1934	1936	Replaced by Dubuffet's *Genuflexion of the Bishop* in 1964
Dietz Edzard (German, 1893-1963)	*At the Theatre,* 1934	1936	Sold, 1955
Edouard Goerg	*Maria Lani,* c. 1930	1937	Withdrawn, 1956 Sold, 1971
Salvador Dali (Spanish, b. 1904)	*Shades of Night Descending,* 1931	1937	Traded for Dali's *Inventions of the Monsters* in 1943
Chaim Soutine	*Dead Fowl,* c. 1926	1937	(p. 28)
Marc Chagall (Russian, 1889-1985)	*The Praying Jew (Rabbi of Vitebsk),* 1923 (3rd version)	1937	(p. 29)
Raoul Dufy	*Open Window, Nice,* 1928	1937	(p. 27)
André Derain	*Stag Hunt,* 1938	1938	Sold, 1957
Amedeo Modigliani (Italian, 1884-1920)	*Madam Pompadour,* 1915	1938	(p. 30)
Giorgio de Chirico (Italian, 1888-1978)	*The Philosopher's Conquest,* 1914	1939	(p. 32)

Artist	Title/Date	Acquired	Disposition
Oskar Kokoschka (Austrian, 1886-1980)	*Elbe River Near Dresden,* 1919	1939	(p. 31)
Pablo Picasso (Spanish, 1884-1973)	*Head of a Woman,* 1909	1940	(p. 33)
José Clemente Orozco (Mexican, 1883-1949)	**Zapata Entering a Peasant's Hut,* 1930	1941	Replaced by Balthus's *Patience* in 1964
Rufino Tamayo (Mexican, b. 1899)	**Woman with a Bird Cage,* 1941	1942	Replaced by Monet's *Etretat* in 1973
Salvador Dali	*Inventions of the Monsters,* 1937	1943	(p. 34)
Diego Rivera (Mexican, 1886-1957)	*Mother Mexico,* 1935	1945	Sold, 1958
Yves Tanguy (French, 1900-1955)	*The Rapidity of Sleep,* 1945	1946	(p. 35)
El Greco (Domenico Theotocopuli) (Spanish, 1541-1614)	*The Feast in the House of Simon,* c. 1610/14	1949	(p. 37)
Fernand Léger (French, 1881-1955)	*Follow the Arrow,* 1919	1953	(p. 38)
Vincent van Gogh (Dutch, 1853-1890)	*The Drinkers,* 1890	1953	(p. 40)
Paul Cézanne (French, 1839-1906)	*Apples on a Tablecloth,* c. 1886/90	1953	(p. 39)
Paul Cézanne	*House on the River,* 1885/90	1956	(p. 42)
Paul Gauguin (?)	*Of Human Misery (Brittany Scene),* *1889*	1956	Replaced by Degas's *Portrait After a Costume Ball* in 1961 Sold, 1961
Vincent van Gogh	*Self-Portrait,* c. 1886/87	1956	(p. 41)
Odilon Redon (French, 1840-1916)	*Evocation,* c. 1905/10	1956	(p. 43)
Oskar Kokoschka	*Portrait of Ebenstein,* 1908	1956	(p. 45)

Artist	Title/Date	Acquired	Disposition
Joan Miró (Spanish, 1893-1983)	*Portrait of a Woman, (Juanita Obrador),* 1918	1957	(p. 44)
Henri Matisse	*A Dancer in Red,* (date unknown)	1959	Traded for Delaunay's *Champs de Mars* in 1959
Robert Delaunay (French, 1882-1941)	*Champs de Mars (The Red Tower,)* 1911	1959	(p. 47)
Edgar Degas (French, 1834-1917)	*Portrait After a Costume Ball (Mme. Dietz-Monin),* 1877/79	1961	(p. 48)
Ben Nicholson (British, 1894-1982)	*November, 1956 (Pistoia),* 1956	1962	(p. 49)
Marcel Ordinaire (French, 1848-1896)	**Landscape,* 1867	1963	Accessioned as a Courbet Replaced by Magritte's *Time Transfixed* in 1970
Edouard Manet (French, 1832-1883)	*Young Woman,* c. 1879	1963	(p. 50)
Balthus (Count Balthasar Klossowski de Rola) (French, b. 1903)	*Patience,* 1943	1964	(p. 51)
Jean Dubuffet (French, 1901-1985)	*Genuflexion of the Bishop,* 1963	1964	(p. 52)
René Magritte (Belgian, 1898-1967)	*Time Transfixed,* 1938	1970	(p. 55)
Claude Monet (French, 1840-1926)	*Etretat,* 1883	1973	(p. 56)

SELECTED REFERENCES

Balthus (Count Balthasar Klossowski de Rola), *Patience*, 1943

London. Tate Gallery. *Balthus: A Retrospective Exhibition*, exh. cat. Introduction by John Russell. London: Arts Council of Great Britain, 1968; pp. 20, 60 (ill.); cat. no. 20.

Paris. Centre Georges Pompidou. *Balthus*, exh. cat. Paris: Musée National d'Art Moderne, 1983; pp. 59, 69, 160-61 (pl. 28), 290, 351 (ill.); cat. no. 66.

Rewald, Sabine. *Balthus*, exh. cat. Metropolitan Museum of Art. New York: Harry N. Abrams, 1984; p. 108 (ill.); cat. no. 27.

Braque, Georges, *Still Life (Guitar, Fruitbowl, Music Score),* 1919

Isarlov, George. "Georges Braque," *Orbes* 3 (Paris, 1932); p. 88; cat. no. 265.

Mangin, Nicole S. *Catalogue de l'oeuvre de Georges Braque: Peintures 1916-1923*, vol. 6. Paris: Maeght Editeur, 1973; pp. 50 (ill.), 51.

Cézanne, Paul, *Apples on a Tablecloth*, c. 1886/90

New York. Museum of Modern Art. *First Loan Exhibition: Cézanne, Gauguin, Seurat, van Gogh*, exh. cat. 1929; p. 37 (ill.); cat. no. 27.

Venturi, Lionello. *Cézanne: son art – son oeuvre*. Paris: Paul Rosenberg, 1936; vol. 1, p. 174, cat. no. 510; vol. 2, pl. 156, cat. no. 510.

Cézanne, Paul, *House on the River,* c. 1885/90

Albi. Musée Toulouse-Lautrec. *Trésors impressionnistes du Musée de Chicago*, exh. cat. 1980; pp. 49, 69 (ill.); cat. no. 34.

Chagall, Marc, *The Praying Jew (Rabbi of Vitebsk)*, 1923

Arnason, H. Harvard. *History of Modern Art*, rev. ed. New York: Harry N. Abrams, 1977; pp. 290-92 (fig. 464).

Compton, Susan. *Chagall*, exh. cat. London: Royal Academy of Arts, and Weidenfeld and Nicolson, 1985; pp. 37, 186 (ill.); cat. no. 43.

Meyer, Franz. *Mark Chagall*. London: Thames and Hudson, 1964; pp. 221, 234 (ill.), 243, 322, 324, 607n; cat. no. 234.

Venturi, Lionello. *Marc Chagall*. New York: Pierre Matisse Editions, 1945; p. 30.

de Chirico, Giorgio, *The Philosopher's Conquest,* 1914

Rubin, William S. *Dada, Surrealism, and Their Heritage*. New York: Museum of Modern Art, 1968; pp. 77-78 (fig. 101), 80.

Rubin, William S., ed. *De Chirico*, exh. cat. New York: Museum of Modern Art, 1982; p. 149 (pl. 24).

Soby, James Thrall. *The Early Chirico*. New York: Dodd, Mead and Co., 1941; pp. 38-40 (fig. 26).

————. *Giorgio de Chirico*. New York: Museum of Modern Art, 1955; pp. 65, 68-69, 188 (ill.).

Dali, Salvador, *Inventions of the Monsters*, 1937

Arnason, H. Harvard. *History of Modern Art*, rev. ed. New York: Harry N. Abrams, 1977; pp. 366-69, 379 (pl. 164).

Descharnes, Robert. *Salvador Dali: the Work, the Man*. Translated by Eleanor R. Morse. New York: Harry N. Abrams, 1984; pp. 212-13 (ill.).

Rotterdam. Museum Boymans-van Beuningen. *Dali*, exh. cat. 1970; cat. no. 56 (ill.).

Soby, James Thrall. *Salvador Dali*, exh. cat. New York: Museum of Modern Art, 1941; pp. 26, 62 (ill.); cat. no. 33.

Degas, Edgar, *Portrait After a Costume Ball (Mme. Dietz-Monnin)*, 1877/79

Brettell, Richard R., and Suzanne F. McCullagh. *Degas in The Art Institute of Chicago*, exh. cat. Chicago and New York: Art Institute of Chicago, and Harry N. Abrams, 1984; pp. 105 (ill.), 106-09; cat. no. 47.

Guérin, Marcel, ed. *Edgar Germain Hilaire Degas Letters*. Oxford: Bruno Cassirer, 1947; pp. 60-61.

Lemoisne, Paul André. *Degas et son oeuvre*, vol. 2. Paris: Paul Brame et C.M. de Hauke, 1946-49; pp. 302-03 (ill.); cat. no. 534.

Reff, Theodore. "Some Unpublished Letters of Degas," *The Art Bulletin* 50 (Mar. 1968), pp. 90-91.

Werner, Alfred. *Degas Pastels*. New York: Watson-Guptill, 1968; p. 22.

Delaunay, Robert, *Champs de Mars, The Red Tower*, 1911

Habasque, Guy. *Robert Delaunay: du Cubisme à l'art abstrait*. Paris: S.E.V.P.E.N., 1957; p. 261; cat. no. 88.

Harnoncourt, Anne d'. *Futurism and the International Avant-Garde*, exh. cat. Philadelphia: Philadelphia Museum of Art, 1980; cat. no. 84 (ill.).

Paris. Orangerie des Tuileries. *Robert Delaunay,* exh. cat. Introduction by Michel Hoog. Paris: Editions des Musées Nationaux, 1976; pp. 21 (ill.), 54; cat. no. 29.

Rudenstine, Angelica Zander. *The Guggenheim Museum Collection: Paintings 1880-1945*, vol. 1. New York: Solomon R. Guggenheim Foundation, 1976; pp. 104-07.

Dubuffet, Jean, *Genuflexion of the Bishop*, 1963

Barilli, Renato. *Dubuffet: Le Cycle de l'Hourloupe*. Turin: Edizioni d'Arte Fratelli Pozzo, 1976; pp. 27, 30-31 (ill.); cat. no. 33.

Loreau, Max. *Catalogue des travaux de Jean Dubuffet: L'Hourloupe I*, vols. 20-21. Paris: Jean Jacques Pauvert, 1966; p. 100 (ill.); cat. no. 183.

Venice. Centro internazionale delle arti e del costume. *L'Hourloupe di Jean Dubuffet*, exh. cat. Venice: Rizzoli, 1964; cat. no. 33 (ill.).

Dufy, Raoul, *Open Window, Nice*, 1928

Laffaille, Maurice. *Raoul Dufy: Catalogue raisonné de l'oeuvre peint*, vol. 3. Geneva: Edition Motte, 1972-77; p. 256 (ill.); cat. no. 1234.

San Francisco Museum of Art. *Raoul Dufy 1877-1953*, exh. cat. 1954; p. 39; cat. no. 37.

Dufy, Raoul, *Villerville*, c. 1928

Laffaille, Maurice. *Raoul Dufy: Catalogue raisonné de l'oeuvre peint*, vol. 2. Geneva: Edition Motte, 1972-77; p. 305 (ill.); cat. no. 797.

San Francisco Museum of Art. *Raoul Dufy 1877-1953*, exh. cat. 1954; p. 39; cat. no. 41.

Dunoyer de Segonzac, André, *Summer Garden (The Hat with the Scottish Ribbon)*, 1926

Allentown Art Museum. *Four Centuries of Still Life*, exh. cat. Allentown, Pa., 1959; p. 29 (fig. 58); cat. no. 89.

Marchand, Sabine. "André Dunoyer de Segonzac, 1884-1974; A Gracious Individualist," *Art News* 73 (Nov. 1974); p. 58 (ill.).

Santa Barbara Museum of Art. *Fruits and Flowers in Painting*, exh. cat. Santa Barbara, Calif., 1958; p. 30; cat. no. 90.

Forain, Jean Louis, *Sentenced for Life*, c. 1910

Chicago. David and Alfred Smart Gallery. *Artists View the Law in the 20th Century,* exh. cat. Chicago: The University of Chicago, 1977; pp. 13, 21; cat. no. 5.

Faxon, Alicia. *Jean Louis Forain: Artist, Realist, Humanist*, exh. cat. Washington, D.C.: International Exhibitions Foundation, 1982; pp. 38 (ill.), 39; cat. no. 10.

Gauguin, Paul, *The Burao Tree (Te Burao)*, 1892

Rewald, John. *Post-Impressionism from van Gogh to Gauguin*, 3rd ed. rev. New York: Museum of Modern Art, 1978; p. 472 (ill.).

Wildenstein, Georges. *Gauguin*, vol. 1. Paris: Les Beaux-Arts, 1964; pp. 196-97 (ill.); cat. no. 486.

Gauguin, Paul, *Portrait of a Woman in Front of a Still Life by Cézanne (Marie Derrien)*, 1890

Goldwater, Robert. *Paul Gauguin.* New York: Harry N. Abrams, [1957]; pp. 94-95 (ill.).

Roskill, Mark. *Van Gogh, Gauguin and French Painting of the 1880s: A Catalogue Raisonné of Key Works.* Ann Arbor, Mich.: University Microfilms, 1970; pp. 196-97.

_____. *Van Gogh, Gauguin and the Impressionist Circle.* Greenwich, Conn.: New York Graphic Society, 1970; pp. 46-47, 52 (pl. IV), 54 (fig. 29) (listed as *Portrait of Marie Lagadu*).

Wildenstein, Georges. *Gauguin*, vol. 1. Paris: Les Beaux-Arts, 1964; p. 149 (ill.); cat. no. 387.

Gogh, Vincent van, *The Drinkers*, 1890

Faille, Jacob-Baart de la. *The Works of Vincent van Gogh: His Paintings and Drawings.* New York: Reynal and Morrow House, 1970; pp. 637, 684 (ill.); cat. no. F667.

Gogh, Vincent van. *The Letters of Vincent van Gogh to His Brother 1872-1886*, vol. 2. London and Boston: Constable and Houghton Mifflin, 1927; p. 83.

_____. *Further Letters of Vincent van Gogh to His Brother 1886-1889.* London and Boston: Constable and Houghton Mifflin, 1929; pp. 430, 437.

Rewald, John. *Post-Impressionism from van Gogh to Gauguin*, 3rd ed. rev. New York: Museum of Modern Art, 1978; p. 327 (ill.).

Scherjon, W., and Jos. de Gruyter. *Vincent van Gogh's Great Period: Arles, St. Rémy and Auvers sur Oise.* Amsterdam: De Spieghel, 1937; p. 291 (fig. 667).

Gogh, Vincent van, *Self-Portrait*, c. 1886/87

Art Institute of Chicago. *European Portraits 1600-1900 in The Art Institute of Chicago*, exh. cat. Chicago, 1978; pp. 18, 86-87 (ill.); cat. no. 20.

Erpel, Fritz. *Van Gogh: The Self-Portraits.* Greenwich, Conn.: New York Graphic Society, [1969]; p. 19 (pl. 22).

Faille, Jacob-Baart de la. *The Works of Vincent van Gogh: His Paintings and Drawings.* New York: Reynal and Morrow House, 1970; pp. 162, 165 (ill.), 624, 677; cat. no. F345.

Hammacher, Abraham Marie. *Genius and Disaster: The Ten Creative Years of Vincent van Gogh.* New York: Harry N. Abrams, [1968]; pp. 37 (ill.), 183.

Welsh-Ovcharov, Bogomila. *Vincent van Gogh: His Paris Period 1886-1888.* Utrecht: Editions Victorine, 1976; p. 225; cat. no. F345.

El Greco (Domenico Theotocopuli), *The Feast in the House of Simon*, c. 1610/14

Aznar, José Camon. *Dominico Greco.* Madrid: Espasa-Calpe, 1970; pp. 900, 902 (fig. 763), 903.

Cossio, Manuel B. *El Greco.* Madrid: Espasa-Calpe, 1981; pp. 190-91 (ill.), 192, 274; cat. no. 54.

Gudiol, José. *Domenikos Theotokopoulos: El Greco 1541-1614.* Translated by Kenneth Lyons. London: Secker and Warburg, 1973; pp. 277, 281 (fig. 257), 356; cat. no. 231.

Lassaigne, Jacques. *El Greco.* Translated by Jane Brenton. London: Thames and Hudson, 1973; pp. 171-72 (fig. 128).

Vallentin, Antonina. *El Greco.* Translated by Andrew Révai and Robin Chancellor. Garden City, N.Y.: Doubleday, 1955; pp. 240-41 (fig. 79).

Kokoschka, Oskar, *Portrait of Ebenstein*, 1908

Hoffman, Edith. *Kokoschka: Life and Work.* London: Faber and Faber, 1947; pp. 47, 82, 89, 290; cat. no. 11.

Kokoschka, Oskar. *My Life.* Translated by David Britt. New York: Macmillan, 1974; pp. 42-43.

Schweiger, Werner J. *Der Junge Kokoschka: Leben und Werk, 1904-1914.* Vienna: Christian Brandstätter, 1983; pp. 118, 187 (ill.), 262.

Wingler, Hans Maria. *Oskar Kokoschka: The Work of the Painter.* Translated by Frank S.C. Budgen et al. Salzburg: Galerie Welz, 1958; p. 294 (ill.); cat. no. 10.

Kokoschka, Oskar, *Elbe River Near Dresden*, 1919

Boston. Institute of Contemporary Art. *Oskar Kokoschka: A Retrospective Exhibition*, exh. cat. New York: Chanticleer Press, 1948; pp. 24-25, 83 (ill.); cat. no. 27 (listed as *Elbe Bridge, Dresden*).

Hoffman, Edith. *Kokoschka: Life and Work.* London: Faber and Faber, 1947; pp. 165-66, 309; cat. no. 126.

Wingler, Hans Maria. *Oskar Kokoschka; The Work of the Painter.* Translated by Frank S.C. Budgen et al. Salzburg: Galerie Welz, 1958; p. 308 (ill.); cat. no. 131.

Léger, Fernand, *Follow the Arrow*, 1919

Adelaide. Art Gallery of South Australia. *Fernand Léger*, exh. cat. New York: Museum of Modern Art, 1976; cat. no. 5 (ill.).

Buffalo. Albright-Knox Art Gallery. *Fernand Léger*, exh. cat. New York: Abbeville Press, 1982; pp. 33, 61, 78 (ill.); cat. no. 15.

Magritte, René, *Time Transfixed*, 1938

Hammacher, Abraham Marie. *René Magritte.* Translated by James Brockway. New York: Harry N. Abrams, 1973; pp. 114-15 (pl. 25).

Soby, James Thrall. *René Magritte*, exh. cat. New York: Museum of Modern Art, 1965; p. 37 (ill.); cat. no. 38.

Torczyner, Harry. *Magritte: Ideas and Images.* Translated by Richard Miller. New York: Harry N. Abrams, 1977; pp. 81 (ill.), 82-83; cat. no. 114.

Vovelle, José. *Le Surréalisme en Belgique.* Brussels: A. de Rache, 1972; p. 116 (fig. 121).

Manet, Edouard, *Young Woman*, c. 1879

Hanson, Anne Coffin. *Edouard Manet: 1832-1883*, exh. cat. Philadelphia and Chicago: Philadelphia Museum of Art and Art Institute of Chicago, 1966; pp. 168 (ill.), 169; cat. no. 156.

_____ . *Manet and the Modern Tradition*. New Haven and London: Yale University Press, 1977; pp. 164, 170 (pl. 107).

Paris. Galeries nationales du Grand Palais. *Manet 1832-1883*, exh. cat. Paris: Editions des Musées Nationaux, 1983; p. 25 (fig. 10).

Rouart, Denis, and Daniel Wildenstein. *Edouard Manet: Catalogue raisonné*, vol. 1. Lausanne: Bibliothèque des Arts, 1975; pp. 240-41 (ill.); cat. no. 308.

Matisse, Henri, *Still Life with Geranium Plant and Fruit*, 1906

Barr, Alfred H., Jr. *Matisse: His Art and His Public*. New York: Museum of Modern Art, 1951; pp. 92, 110, 558.

Zurich. Kunsthaus. *Henri Matisse*, exh. cat. 1982; cat. no. 21 (ill.).

London. Hayward Gallery. *Henri Matisse, 1869-1954*, exh. cat. London: Arts Council of Great Britain, 1968; pp. 81 (ill.), 162; cat. no. 36.

Paris. Galeries Nationales du Grand Palais. *Henri Matisse, Exposition du centenaire*, 12th ed. rev. Paris: Editions des Musées Nationaux, 1970; pp. 72-73, 156 (ill.).

Miró, Joan, *Portrait of a Woman (Juanita Obrador)*, 1918

Dupin, Jacques. *Joan Miró: Life and Work*. Translated by Norbert Guterman. New York: Harry N. Abrams, 1962; pp. 80-81, 505 (ill.); cat. no. 53.

Lassaigne, Jacques. *Miró*. Translated by Stuart Gilbert. Geneva: Albert Skira, 1963; pp. 21, 23 (ill.).

Paris. Galeries Nationales du Grand Palais. *Joan Miró*, exh. cat. Paris: Editions des Musées Nationaux, 1974; p. 110 (ill.); cat. no. 4.

Washington, D.C. Hirshhorn Museum and Sculpture Garden. *Miró: Selected Paintings*, exh. cat. Washington D.C.: Smithsonian Institution, 1980; pp. 16 (fig. 5), 56 (ill.); cat. no. 7.

Modigliani, Amedeo, *Madam Pompadour (Beatrice Hastings)*, 1915

Lanthemann, J. *Modigliani 1884-1920: Catalogue raisonné*. Florence: Edition Vallecchi, 1970; pp. 112, 178 (ill.); cat. no. 74.

Mann, Carol. *Modigliani*. London: Thames and Hudson, 1980; pp. 109-10 (ill.); cat. no. 75.

Paris. Musée d'Art Moderne. *Amedeo Modigliani 1884-1920*. 1981; pp. 15, 85, 115 (ill.); cat. no. 26.

Monet, Claude, *Etretat*, 1883

Art Institute of Chicago. *Paintings by Monet*, exh. cat. 1975; pp. 31, 112 (ill.); cat. no. 58.

Los Angeles County Museum of Art. *A Day in the Country: Impressionism and the French Landscape*, exh. cat. New York, Harry N. Abrams, 1984; pp. 276-77, 288 (discussions of Etretat paintings).

Wildenstein, Daniel. *Claude Monet: Biographie et catalogue raisonné*, vol. 2. Lausanne: Bibliothèque des Arts, 1979; pp. 168-69 (ill.); cat. no. 1012.

Nicholson, Ben, *November, 1956 (Pistoia)*, 1956

Ben Nicholson: Drawings, Paintings, and Reliefs 1911-1968. Introduction by John Russell. London: Thames and Hudson, 1969; p. 313 (ill.); cat. no. 139.

Picasso, Pablo, *Head of a Woman*, 1909

Burns, Edward, ed. *Gertrude Stein on Picasso*. New York: Liveright, 1970; p. 80 (ill.).

Daix, Pierre, and Joan Rosselet. *Picasso: The Cubist Years, 1907-1916*. Boston: New York Graphic Society, 1979; p. 244 (ill.); cat. no. 287.

New York. Museum of Modern Art. *Four Americans in Paris: The Collections of Gertrude Stein and Her Family*, exh. cat. 1970; pp. 95 (ill.), 171.

Redon, Odilon, *Evocation*, c. 1905/10

Berger, Klaus. *Odilon Redon: Fantasy and Colour*. Translated by Michael Bullock. New York: McGraw-Hill, 1965; p. 213; cat. no. 423.

New York. Museum of Modern Art. *Odilon Redon, Gustave Moreau, Rodolphe Bresdin*, exh. cat. 1961; p. 174; cat. no. 35.

Soutine, Chaim, *Dead Fowl*, c. 1926.

Courthion, Pierre. *Soutine: Peintre de déchirant*. Lausanne: Edita, 1972; pp. 79 (ill.), 249 (ill.).

Munster. Westfälisches Landesmuseum. *Chaim Soutine 1893-1943*, exh. cat. Stuttgart: Verlag Gerd Hatje, 1982; pp. 208 (ill.), 246; cat. no. 65.

Paris. Orangerie des Tuileries. *Soutine*, exh. cat. Paris: Editions des Musées Nationaux, 1973; pp. 29 (ill.), 81; cat. no. 24 (listed as *Le Dindon*).

Werner, Alfred. *Chaim Soutine*. New York: Harry N. Abrams, 1977; p. 59 (fig. 70).

Soutine, Chaim, *Small Town Square, Vence*, 1929

Courthion, Pierre. *Soutine: Peintre de déchirant*. Lausanne: Edita, 1972; pp. 96 (ill.), 274 (listed as *L'Arbre de Vence*).

Tuchman, Maurice. *Chaim Soutine, 1893-1943*, exh. cat. Los Angeles: Los Angeles County Museum of Art, 1968; pp. 54, 126 (ill.); cat. no. 72.

Werner, Alfred. *Chaim Soutine*. New York: Harry N. Abrams, 1977; pp. 136-37 (fig. no. 36).

Tanguy, Yves, *The Rapidity of Sleep*, 1945

Hartford, Conn. Wadsworth Atheneum. *Yves Tanguy, Kay Sage*, exh. cat. 1954; fig. 3; cat. no. 22.

Matisse, Pierre. *Yves Tanguy: Un Recueil de ses oeuvres/A Summary of his Works*. New York, 1963; p. 156 (ill.); cat. no. 343.

Soby, James Thrall. *Yves Tanguy*, exh. cat. New York: Museum of Modern Art, 1955; pp. 19, 52 (ill.).

Toulouse-Lautrec, Henri de, *In the Circus Fernando: The Ringmaster*, 1888

Albi. Musée Toulouse-Lautrec, *Trésors impressionnistes du Musée de Chicago*, exh. cat. 1980; pp. 20 (ill.), 69; cat. no. 38.

Dortu, M.G. *Toulouse-Lautrec et son oeuvre*, vol. 2. New York: Paul Brame et C.M. de Hauke, 1971; p. 146 (ill.); cat. no. P.312.

Perruchot, Henri. *La Vie de Toulouse-Lautrec*. Paris: Hachette, 1958; pp. 145, 152, 157, 161.

Stuckey, Charles F. *Toulouse-Lautrec: Paintings*, exh. cat. Chicago: The Art Institute of Chicago, 1979; pp. 124 (ill.), 125-29; cat. no. 32.